HOW DO WE LOOK?

———

THE EYE OF FAITH

CIVILISATIONS

HOW DO WE LOOK?

MARY BEARD

THE EYE OF FAITH

P

PROFILE BOOKS

First published in Great Britain in 2018 by
Profile Books Ltd
3 Holford Yard, Bevin Way
London WC1X 9HD

www.profilebooks.com

Published in conjunction with the BBC's *Civilisations* series
'Civilisations' Programme is the copyright of the BBC

1 3 5 7 9 10 8 6 4 2

Designed by James Alexander at Jade Design
Printed and bound in Italy by L.E.G.O. S.p.A.

A CIP catalogue record for this book is available from the British Library.

ISBN 978 1 78125 9993
eISBN 978 178283 4205

FSC
www.fsc.org
MIX
Paper from
responsible sources
FSC® C023419

The paper this book is printed on is certified by the Forest Stewardship Council ® (FSC®). The printer holds FSC chain of custody CSQA-COC-042596.

To Matt Hill and the team

CONTENTS

PART TWO: THE EYE OF FAITH

———

INTRODUCTION: CIVILISATIONS AND BARBARITIES

'Civilisation' has always been contested, argued over and impossible to pin down. In 1969 Kenneth Clark opened his BBC series *Civilisation* by reflecting on the concept itself: 'What is civilisation?' he asked. 'I don't know. I can't define it in abstract terms – yet. But I think I can recognise it when I see it.' This betrayed a certain lofty self-confidence in his own cultural judgement; but Clark was also acknowledging the ragged and shifting edges of the category.

This book is written in the conviction that what we *see* is as important to our understanding of civilisation as what we read or hear. It celebrates a dazzling array of human creativity over thousands of years and across thousands of miles, from ancient Greece to ancient China, from sculpted human heads in prehistoric Mexico to a twenty-first century mosque on the outskirts of Istanbul. But it also prods at some of our certainties about how art works and how it should be explained. For it is not only about the men and women who – with their paints and pencils, their clays and

chisels – created the images that fill our world, from cheap trinkets to 'priceless masterpieces'. It is even more about the generations of humankind who have used, interpreted, argued over and given meaning to those images. One of the most influential art historians of the twentieth century, E. H. Gombrich, once wrote, 'There really is no such thing as art. There are only artists.' I am putting the viewers of art back into the frame. Mine is not a 'Great Man' view of art history, with all its usual heroes and geniuses.

I concentrate on two of the most intriguing and contested themes in human artistic culture. Part One highlights the art of the body, focusing on some very early depictions of men and women around the world, asking what they were for and how they were seen – whether the colossal images of a pharaoh from ancient Egypt or the terracotta warriors buried with the first emperor of China. Part Two turns to images of God and gods. It takes a wider time range, reflecting on how all religions, ancient and modern, have faced irreconcilable problems in trying to picture the divine. It is not just some particular religions, such as Judaism or Islam, that have worried about such visual images. All religions throughout history have been concerned about – and have sometimes fought over – what it means to represent God, and they have found elegant, intriguing and awkward ways to confront that dilemma.

The violent destruction of images is one end of an artistic spectrum that has 'idolatry' at the other.

Part of my project is to expose the very long history of *how we look*. All over the world ancient art, its debates and its controversies still matter. In the West, the art of classical Greece and Rome in particular – and the different engagement people have had with that tradition, over many centuries – still has an enormous impact on modern viewers, even if we do not always recognise it. Western assumptions about what a 'naturalistic' representation of the human body *is* date back to a particular artistic revolution in Greece around the turn of the sixth and fifth centuries BCE. And many of our ways of talking about art continue the conversations of the classical world. The modern idea that the female nude implies the existence of a predatory male gaze was not first thought up, as is often imagined, in the feminism of the 1960s. As Part One will explain, what is believed to be the very first life-sized statue of a female nude in classical Greece – a fourth-century BCE image of the goddess Aphrodite – provoked exactly the same kind of debate. And some of the earliest intellectuals that are known to us argued fiercely about the rights and wrongs of portraying gods in human form. One sixth-century BCE Greek philosopher sharply observed that if horses and cattle could paint and sculpt, they would

represent the gods just like themselves – as horses and cattle.

Clark's opening question – '*What is civilisation?*' – is one of my own main questions too. The two parts of this book are based on two programmes I wrote for the new BBC series of *Civilisations*, first broadcast in 2018. This was an attempt not to 're-make' Clark's original version, but to take a fresh look at its themes with a much wider frame of reference, moving outside Europe (Clark once or twice strayed across the Atlantic, but that was all), and back into prehistory. That is what the plural in the new title indicates.

I am even more concerned than Clark with the discontents and debates around the idea of civilisation, and with how that rather fragile concept is justified and defended. One of its most powerful weapons has always been 'barbarity': '*we*' know that '*we*' are civilised by contrasting ourselves with those we deem to be un-civilised, with those who do not – or cannot be trusted to – share our values. Civilisation is a process of exclusion as well as inclusion. The boundary between 'us' and 'them' may be an internal one (for much of world history the idea of a 'civilised woman' has been a contradiction in terms), or an external one, as the word 'barbarian' suggests; it was originally a derogatory and ethnocentric ancient Greek term for foreigners you could not understand, because they spoke in an incomprehensible babble: 'bar-bar-bar ...' The

inconvenient truth, of course, is that so-called 'barbarians' may be no more than those with a different view from ourselves of what it is to be civilised, and of what matters in human culture. In the end, one person's barbarity is another person's civilisation.

Wherever possible I try to see things from the other side of the dividing line, and to read civilisation 'against the grain'. I shall be looking at some images from the distant past with the same suspicious eyes that we usually keep for those in the modern world. It is important to remember that plenty of ancient Egyptian viewers, or ancient Romans, may have been just as cynical about the colossal statues of their rulers as we now are about the parade of images of modern autocrats. And I shall be looking at some of those on the losing, as well as the winning, sides in the historic conflicts over images, and over what should and should not be represented, or how. Those who destroy statues and paintings – whether in the name of religion or not – are regularly seen in the West as some of history's worst barbarian thugs, and we lament the works of art that, thanks to these 'iconoclasts', we have lost. But, as we shall see, they have their own story to tell too, even their own artfulness.

But let's begin in Mexico, with the very earliest image in the book ...

1

HOW DO WE LOOK?

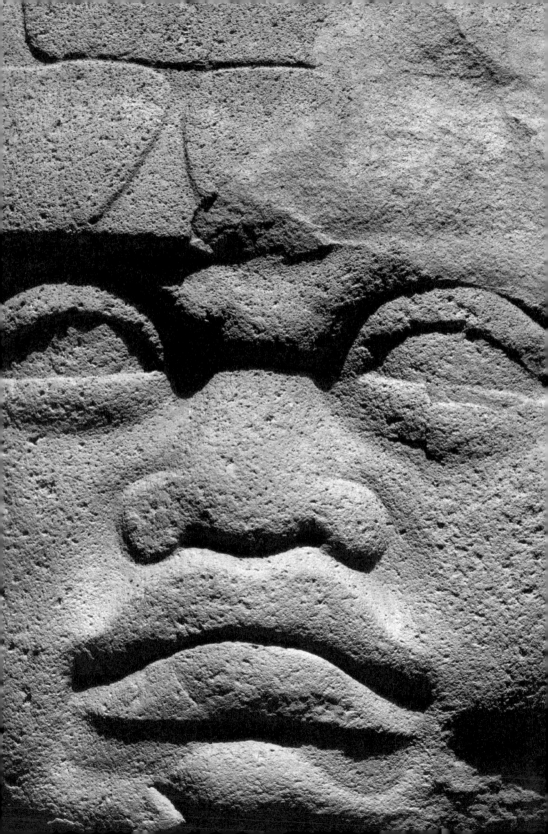

PROLOGUE: HEADS AND BODIES

There are many places where you can come face-to-face with the ancient world, but there are few as surprising as a corner of the Mexican jungle, which is home to a colossal stone head about 3,000 years old. Almost disconcertingly vast, more than seven-feet tall (with eyeballs nearly a foot across) and weighing in at almost twenty tons, it was made by the Olmec, the earliest known civilisation in central America. There is rather more detail to it than appears at first sight. Between his lips (and it almost certainly is a *he*), you can just about glimpse his teeth; his irises are traced out on his eyes; he has a furled, slightly frumpy brow – and on top there sits an elaborate, patterned helmet. It is hard not to feel just a little bit moved by the close encounter with an image of a person from the distant past. Despite that distance in time, and despite the fact that he is, after all, just

1. Eyeball to eyeball. Close up, this ancient Olmec head (Fig. 2) betrays the distinctive pattern of his helmet and the faint outline of the irises of his eyes.

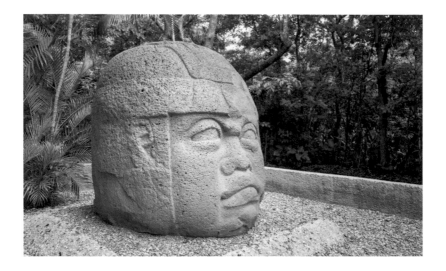

a face of stone, it is hard not to feel some sense of shared humanity.

But the more we ponder it, the more enigmatic the head becomes. Ever since it was rediscovered in 1939, it has defied explanation. Why is it so big? Was he a ruler or perhaps a god? Was it a portrait of a particular individual, or something much less specific than that? Why is it just a head – and not even a complete one at that, but severed at the chin? And what on earth was the image *for*? It was carved using only stone tools, out of a single block of basalt that came from more than fifty miles away from where the head was found. It could not have been made without huge amounts of time, effort and human resources. But why?

The Olmec have left us no written record and few clues about themselves beyond their art and archaeology: the

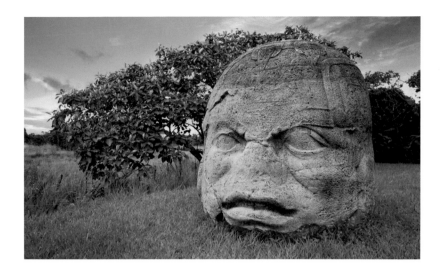

*2, 3. Two colossal heads originally from the Olmec site at La Venta –
of strikingly similar style, both truncated at the chin. The impressive
specimen I describe is on the right, his slightly open lips allowing a
glimpse of his teeth.*

traces of towns, villages and temples, pottery, miniature
sculpture and at least sixteen other colossal heads. We do
not even know what they called themselves: the name
'Olmec' – meaning 'rubber people' – was given to the
people who lived in the region by the Aztec in the fifteenth
and sixteenth centuries CE, and has become a convenient
label for the prehistoric population who lived there. And
it is still debated how far the 'Olmec style' in art reflects a
unified people, with a shared identity, culture or politics.
Nonetheless, whatever mystery surrounds them, the Olmec

21

have left us a powerful in-your-face reminder that across the world, when people first made art they made it about themselves. From the very beginning art has been about *us*.

This section explores early images of the human body from many different places in the world: from classical Greece and Rome to ancient Egypt and the very first period of imperial China. I want to answer some of the questions raised so starkly by that giant Olmec head. What were these images of the body for? What part did they play in the societies that created them? How were they seen and understood by the men and women who lived with them? I will be focusing on the people who *looked* at this art as much as on the artists who *made* it. And not only in the past: I want to show how one way of representing the body, which goes directly back to classical Greece, became – and remains – more influential than any other in shaping western ways of seeing. Returning finally to the Olmec, we will see that *how we look* can confuse, even distort, our understanding of civilisations beyond our own.

But first, half a world away from the Mexican jungle and almost a thousand years later, let's watch a Roman emperor seeing the sights of ancient Egypt.

A SINGING STATUE

In November 130 CE, Hadrian and his entourage arrived in the Egyptian city of Thebes, modern Luxor, some 500 miles from the Mediterranean coast. By then, the imperial party – not just the emperor and his wife Sabina, but presumably a whole retinue of servants and slaves, advisers and confidants, domestic staff and security men, and any number of hangers-on – had been on the road (and the river) for months on end. By far the most committed and enthusiastic traveller of all Roman rulers, Hadrian seems to have got everywhere; he was part curious tourist, part devout pilgrim, and part canny ruler who wanted to find out what was going on in his empire. On this occasion, the atmosphere around the emperor must have been somewhat tense, for only a few weeks earlier, Hadrian had lost his greatest love: not Sabina, but a young man by the name of Antinous, who was also in the imperial party, and who drowned mysteriously in the waters of the Nile. Murder, suicide and a strange ritual of human sacrifice have all been suggested.

Not even personal tragedy, or guilt, was going to deflect the emperor from paying a visit to what was then one of the most famous heritage sites in Egypt, and one of the greatest five-star tourist attractions in the whole of the

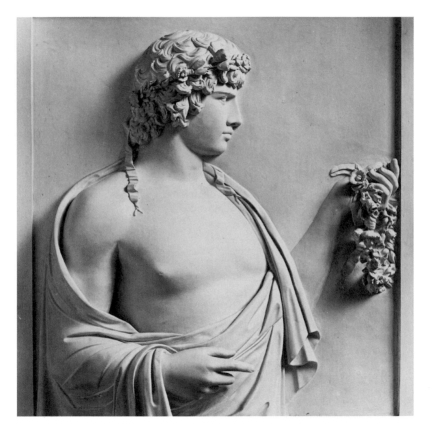

4. This marble relief of Antinous, holding a garland in his hand, is supposed to have been discovered in Hadrian's villa at Tivoli, just outside Rome, in 1753 – suggesting that it was a commemoration of the young man put up by the emperor. But some archaeologists have found the soft eroticism of the piece too good to be true and wondered if it is a fake, or at least very imaginatively restored.

ancient world. This was a pair of vast statues of the Pharaoh Amenhotep III, sixty-five feet high, originally put up in the fourteenth century BCE to stand guard outside his tomb. By Hadrian's day, almost a millennium and a half later, the connection with the pharaoh had been partly forgotten, and one of them at least had been re-identified as a statue of the mythical Egyptian king Memnon: the son of the goddess of the Dawn, who had fought, it was said, on the Trojan side in the Greek war against Troy and had been killed by Achilles. This was the statue that attracted Roman tourists, not so much for its size but for the more surprising fact that it could sing. If you were lucky, and came early in the morning, you might experience a moment of wonder, when Memnon cried out to greet his mother at break of day. The statue made a noise that one down-to-earth ancient traveller compared to a lyre with a broken string.

Quite how this sound was produced is a puzzle. One or two sceptical Romans suspected a trick by some boys hiding round the back of the statue with just such an off-key lyre. The usual modern theory is a more scientific one: that after an earthquake had damaged the stone figure, it produced a natural wheezing sound through its cracks as it warmed up and dried out in the morning sun. It certainly stopped singing later, after it had undergone a major Roman repair job. Even in its prime, it could not be relied upon to make a sound every day, and it was taken as a very good

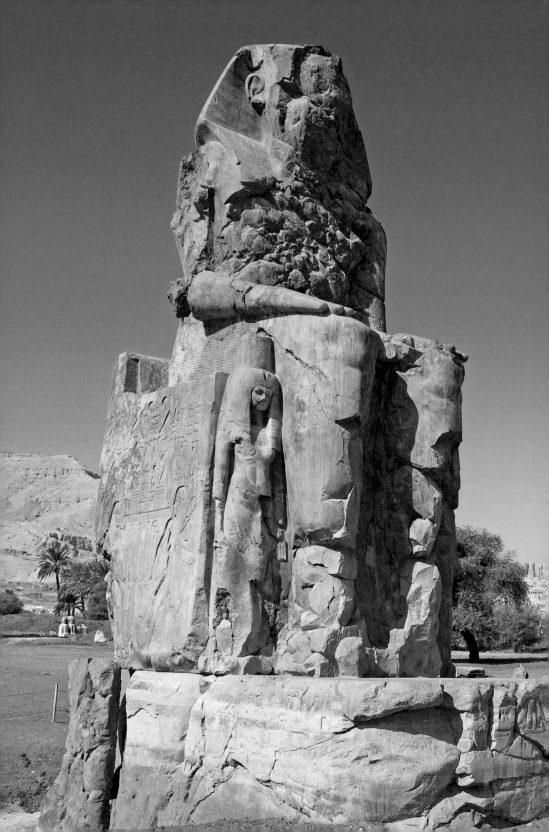

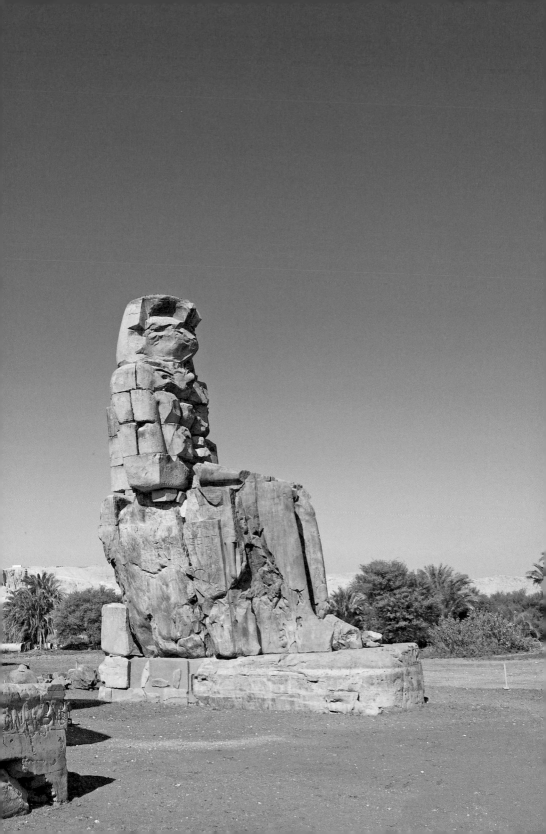

omen if it did. When the imperial party visited, Memnon remained resolutely silent on the first day – a PR disaster in the making, and a clear hint that the noise was not produced by anything so biddable (or bribe-able) as 'boys round the back'.

We know of the bad luck on that first morning because one member of Hadrian's group recorded the occasion in verse. She was a well-connected lady called Julia Balbilla: courtier, descendant of Near Eastern royalty, and sister of Philopappos, whose tomb monument, on 'Philopappos Hill', is even now a prominent landmark in modern Athens. Her verses, more than fifty lines of them in Greek, in four separate poems, were carved onto the left foot and leg of the statue itself, where they can still be seen and read, along with over 100 more tributes to Memnon and his powers composed by other ancient travellers. There is no need to imagine that Balbilla, or any of the other, mostly well-heeled, visitors, clambered up onto the statue, chisel in hand, to do the carving themselves. They presumably handed over their words on papyrus to some local craftsman or official, who – no doubt for a fee – would find an empty spot on what was by the early second century a rather crowded leg, and do it on their behalf.

Balbilla's poetry is not of the highest literary quality

5. The 'Colossi of Memnon', the singing statue on the right.

('some is atrocious' is the brutal judgement of one modern critic); but it is the most extraordinary high-end graffiti, almost adding up to a diary of her Memnon experience, and giving us a first-hand glimpse of what it felt like to be here. She manages to invent a flattering excuse for the initial silence. In the poem headed, 'When on the first day we did not hear Memnon', she writes (in typically lumpy style):

> Yesterday Memnon received the emperor's wife without a sound
> So that beautiful Sabina would come back here again.
> For the lovely form of our empress pleases you ...

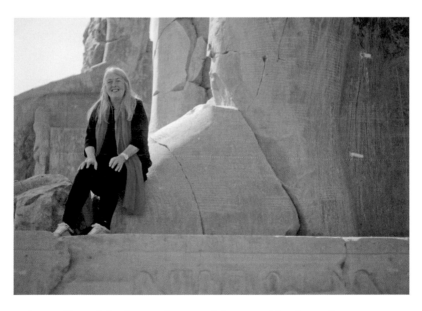

6. I was allowed climb onto the statue's foot, just like the workmen centuries ago who would have been paid to transcribe the reactions of ancient tourists, impressed – or not – by the miraculous singing.

After Hadrian actually hears Memnon on a later morning, Balbilla's tone becomes rather more triumphalist. She compares the noise to 'ringing bronze' rather than a broken lyre, and puts down the three cries (not just the usual one) to the special favour of the gods for her lord. In other lines she ventures to suggest that Memnon will last forever: 'I do not think this statue of yours will be destroyed.' She would, I am sure, be delighted to know that so far she has been proved right.

There is something touching about being able to tread in the footsteps of Hadrian's party, to share their gaze almost 2,000 years later, even if sadly we cannot hear the singing. But, even more important, this whole story shows one of the ways that ancient people interpreted statues and paintings of human beings: not as passive art works but as active players with roles to perform in the lives of those who viewed them. Whether the singing was hype or a trick or a natural miracle, Memnon's statue reminds us very powerfully that images often *did something*. And Balbilla's poetry especially reminds us that the history of art is not just a history of artists, of the men and women who painted

7. *This section of Memnon's foot (the particular crack is also visible in Fig. 6) gives a good impression of how the graffiti (mostly short poems in Greek) are crammed together on the 'skin' of the statue. On the far left is another poem by Balbilla: 'I Balbilla heard from the speaking stone the divine voice of Memnon ...'*

and sculpted. It's also a history of the men and women, who like her looked and interpreted what they saw, and the changing ways in which they did so.

If we want to understand images of the body, we really have to put those viewers back into the picture of art. And there is no better place to do that than another site in the ancient world that was also very close to the emperor Hadrian's heart, into which he poured his money and where he often visited. That is the city of Athens in Greece, whose culture we can explore very closely, and almost from the inside, through the thousands of images and millions of words – in poetry, prose, scientific theory and philosophical speculation – the ancient Athenians have left us.

GREEK BODIES

From about 700 BCE, seven centuries after those Egyptian colossi had first been erected, the Athenians embarked on one of the most radical European experiments in urban living. Athens was never large in our terms (perhaps only 30,000 male citizens participated in the democracy of the middle of the fifth century BCE), but in some ways it *was* like a modern metropolis, with people of different classes and backgrounds, living together and inventing some of the basic principles of what we call 'politics' (derived from the Greek word *polis*, or 'city'). It was always a much stranger and more brutal culture than the high-minded and rather sanitised version that we are often peddled. Those Athenian 'inventions' of democracy, theatre, philosophy, history and their highly theorised reflections on what it was to be a civilised human being and a free citizen went hand in hand with the exploitation of slaves, women and so-called 'barbarians'. And it was all underpinned by an intense investment in the youthful, athletic human body, almost as if that was a physical guarantee of moral and political virtue,

or an encouragement to it. The ideal male citizen was, in the Athenian stereotype, both 'perfectly formed' and 'good' (*kalos kai agathos*, as the influential Greek cliché put it).

With that came a whole 'city of images' of the human body. Athenian art, and Greek art more generally, almost never means landscape or still life. It means statues and drawings, paintings and models of *human beings*. These images were everywhere. Far from the safe confines of the modern museum with its classical statues passively lined up along the gallery walls, they were out in the world, playing their part, almost a parallel population alongside the living. Imagine the public plazas and the shady sanctuaries full of people in marble and bronze, as well as people in flesh and blood. Imagine the gymnasia with the young athletes exercising naked, being admired from the side-lines, not only by their fans, but by ranks of sculpted athletes, equally well toned, equally beautiful in Greek terms. And imagine, in particular, the men at their drinking parties, or the women at their spinning and weaving, looking at the distinctive red and black of Athenian ceramics with designs which reflected their own roles, as Athenians, back to them.

Gorgeous as they are, and now museum masterpieces for us, most of these pots were originally everyday household crockery, the kind of thing you might have found on the kitchen shelf in an Athenian house. They were produced in thousands from around 600 BCE, not in artists' studios,

but in a clutter of rival workshops that made up the 'potters' quarter' of the ancient city, the *Kerameikos* (to which our own word 'ceramic' is connected); those luscious colours were the result of an industrial process that involved multiple firings, at different temperatures, and different slip-wares carefully applied to the surface. It was these pots – covered as they were with pictures of people – that made a particular form of the human body ubiquitous across Athens, and afterwards throughout the western world, and more widely.

Two very different specimens, both produced in the fifth century BCE, show clearly how this image-making works, and point to the important links between the ancient viewer and the figures on the pots. The larger (Fig. 9) is a wine cooler, which would have been brought onto the table of up-market men's drinking parties (whether it held the wine and was then plunged into a bowl of cold water, or whether it held the cold water and was then plunged into a bowl of wine is not entirely clear). The smaller (Fig. 8) is an ordinary water jug, which looks as if it has been well used. But the images on both of them are much more than mere decoration, and a reflection of more than simply an aesthetic interest in the human form or a desire to mirror the human world round about. This was no crude campaign in social instruction, but taken together they were telling the Athenians *how to be Athenian*. We might compare

– whatever the very different contexts – the message of western advertisements in the 1950s and later, suggesting ways of ideal living through the imagery of consumer goods.

On the water jug we see the perfect Athenian woman. She is not poor. She is sitting down, and being handed her

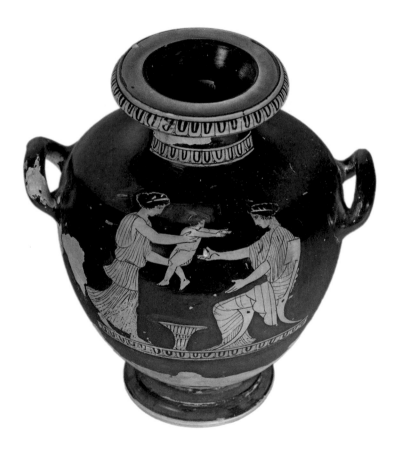

8. This is an economical visual shorthand for the expected role of the elite Athenian woman: producing cloth and children (though not without the help of a slave – who here hands the baby to her mistress).

baby by a slave or servant girl. At her feet she has her wool basket. That about sums up the answer to the question: what were the wives of Athenian citizens supposed to be *for*? They were for making babies and making wool. The pot, which would very likely be part of the female domestic world, is offering a template for how to be an Athenian wife.

The wine cooler is different. It is covered with satyrs, mythical creatures who are half human and half animal (as their goaty ears and tails tell us). They are all over the pot, getting absolutely plastered. One is balancing his goblet in a very silly place (a trick that was so shocking to some prudish Victorian curators that they temporarily painted out the erect penis, and so produced the even more incredible feat of a goblet hovering in mid-air). Another is having wine poured straight into his mouth from an animal-skin flask, which is more or less the ancient equivalent of downing whisky neat, from the bottle.

What was this doing on the table in the man's world of the drinking party? It may be tempting to spot here the equivalent of the modern health warning on the cigarette packet: however much you may be enjoying yourselves, do not drink too much, because it will turn you into the coarse, unruly kind of creature that you see here. But these pots were doing nothing so simple as transmitting 'government messages'. They were raising much bigger questions. If the images on the water jug were telling Athenian women

37

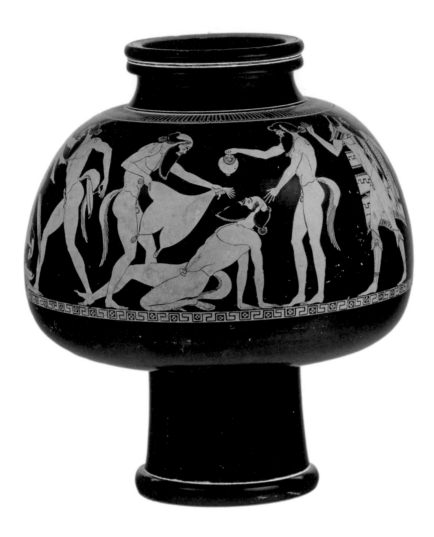

9. The semi-human satyrs break many of the rules of 'civilised' male drinking. The consumption of neat alcohol was not simply excessive; it flouted the basic Greek convention that even wine should be drunk mixed with water. 10. On the right the silly tricks performed by these drunken satyrs also hint at their lack of sexual control – no living creature was safe in their company.

how to be women, this wine cooler pointed to even more difficult issues about where the boundary really lay between civilisation and its absence, between the human and the animal – and to the question of how much wine you had to consume before you really did turn into a beast, and where and how to draw the line between the civilised citizen and those, like the satyrs, whose home was said to be outside the city, in the uncivilised wild.

At this early period in its history Athens was actively inventing itself. It was inventing its rules and its conventions. Without any model ready to hand, the Athenians were constructing the very idea of what it was to live together in an urban community. Contemporary Athenian drama, history and (a little later) philosophy, show just how preoccupied

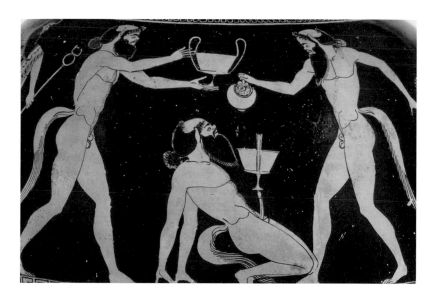

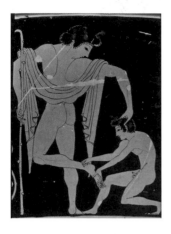

11. An athlete with his slave on a fifth-century BCE Athenian 'krater' (a bowl used for mixing wine and water) clearly demonstrates the hierarchies. The tiny slave tends to the feet of his master, who leans heavily on his head.

writers were with questions of how humanity was to be defined, how a citizen should behave and what counted as 'civilisation'. Their version of humanity is not one that most of us now would feel very comfortable with. It is deeply gendered, and rigidly hierarchical. It is no accident, for example, that when you find a slave depicted on an Athenian pot, they are often shown at literally half the size of an Athenian citizen. And it explicitly derides those who have faces or bodies or habits that somehow do not fit, from barbarous foreigners to the old and ugly, the fat and the flabby. Like it or not, these visual images – whether of humans or hybrids – also played an important part in those debates, advertising to the people who viewed them how they should be, act and *look*.

What we are seeing here are visual images constructing one idea of a civilised human being. But there is even more to it than that.

THE LOOK OF LOSS:
FROM GREECE TO ROME

The *Kerameikos*, or 'potters' quarters', in ancient Athens was a place where two very different images of the human body collided – and two very different functions of those images. The painted pottery, that staple of Athenian everyday life, from the drinking party to the kitchen, was produced under the shadow of one of the main cemeteries of the city, next to the memories of Athenians past and of the marble memorials to the dead. If images helped Athenians live together in the company of each other, they also helped in keeping the dead in the company of the living. One of the most arresting jobs of ancient – as well as modern – sculptures was to be some kind of antidote to death and loss.

No statue brings that home more forcefully than the marble memorial of a young woman unearthed in the 1970s in the countryside around Athens. Her name, written on the inscription underneath, is Phrasikleia – and that means something like 'aware of her own renown'. Carved around 550 BCE, she is one of the most striking of the surviving

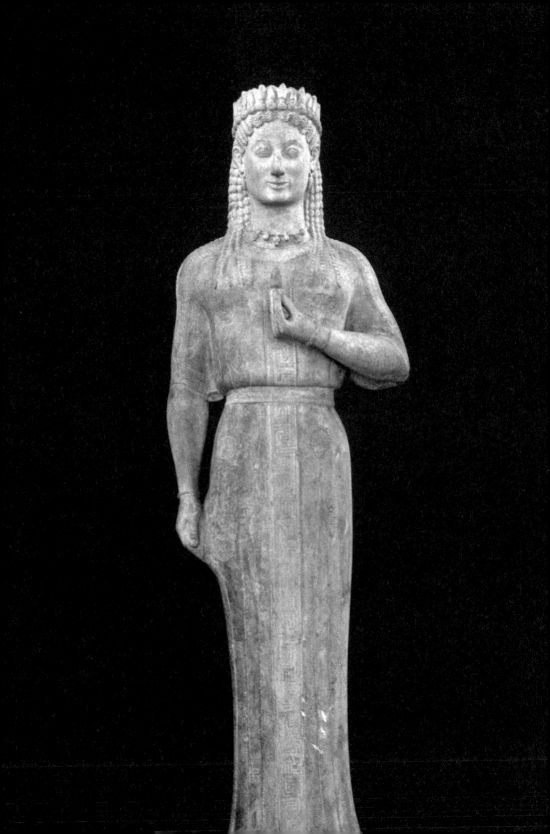

grave markers from the ancient Greek world. She has a wonderfully patterned dress, clothed for eternity in her finest. The traces of red pigment that still remain are a useful reminder that most Greek sculpture was richly, even gaudily, painted; and wearing that strange smile that is so common in early Greek sculpture, she seems to guarantee some kind of 'real life' in the marble. For, in the whole world, it is only living human beings who actually smile.

What is so affecting about Phrasikleia is the way that she engages us as viewers even now. She looks straight out and challenges us to look back at her, and in her hand she holds a flower – keeping it for herself or maybe going to offer it to us, is not clear. The inscription beneath tells us that this is her tomb statue, and it almost lets her speak to us, in her own voice: 'I shall always be called a maiden because I got that name from the gods instead of marriage.' That is to say: 'I died before my wedding day.' How do I look? She challenges our senses and provokes our senses. There is a vivid encounter here between Phrasikleia and her viewers, and one that we can, if we try, still share.

12. *Phrasikleia's memorial is one of the most important finds in Greek sculpture over the last half-century. Attempts to reconstruct the original design of her dress suggest that it featured brightly coloured flowers, rosettes and appliqué metalwork (Fig. 37). Unusually the name of the artist is also recorded on the base: Aristion from the Greek island of Paros.*

Phrasikleia faces death in the most forthright way, resolutely refusing to be forgotten. But can an image of a person actually suspend the loss of them, or even for a moment deny it? Hundreds of years later than Phrasikleia, roughly at the time that Hadrian came to visit the statue of Memnon, some of the haunting faces from Roman Egypt seem to attempt exactly that. They are almost disconcertingly modern and they hint at what must once have been a major tradition of painted portraits in the classical world – though almost all traces of it are lost to us except in those few places where climatic conditions over the centuries have been kind to wood and paint (Egypt is the main one). It is striking that they incorporate many of the tricks that we associate with modern representations of the human face: the modelling in light and shade, and those subtle catch-lights in the eye. At first sight, they look like the kind of portraits that you might hang on a wall (and that is exactly where many of them do hang in modern museums and galleries). But the truth is rather different. These portraits actually belonged on coffins. Most of them have been removed from their original casings, but a few have remained intact.

One of these is the coffin of a young man called Artemidoros, who died in the early second century CE, excavated at Hawara in central Egypt. We know almost nothing more about him than what we see in his painted

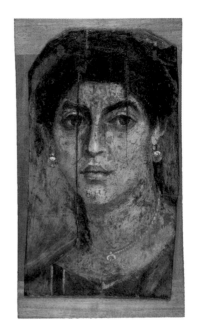

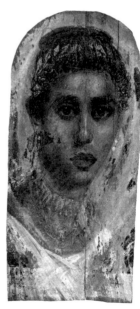

13, 14, 15. *Three mummy portraits from Roman Egypt, now detached from their casings; though painted in the late first – early second century* CE, *they seem strikingly modern. The man at the upper left was perhaps a priest to judge by the unusual head-dress; the woman on the right is pictured in a deep mauve dress (with flecks of white paint catching the light in her earrings); the young woman below is especially richly presented, with a wreath and elaborate jewellery added in gold leaf.*

face and in the words and images that go with it (whether the fractures of his skull revealed by X-ray occurred before or after death is unclear). But the elaborate coffin suggests a well-heeled family and the extravagant decoration betrays a cosmopolitan way of death – and of life. His mummy is a wonderful combination of the traditions of Egypt, Greece and Rome, and a brilliant example of the cultural mix of the ancient Mediterranean. On the casing are typically Egyptian scenes: a picture of a mummy being laid on a couch and those characteristically animal-headed Egyptian gods. His name is Greek and is written in Greek across his front. 'Artemidoros, farewell' it reads (albeit with a careless misspelling in the 'farewell'). His face is a Roman portrait.

Many other cultures had, of course, represented the human face before, but it was the Romans who made individual likeness of this kind very much their own. Roman art was a complex and creative amalgam, often in dialogue with – and developing – Greek styles of representation. But

portraiture was firmly embedded in Roman traditions, and in particular in their rituals of death. The tombs that came to line the roads into the capital greeted the visitor with the faces of the dead. Even more striking, funeral

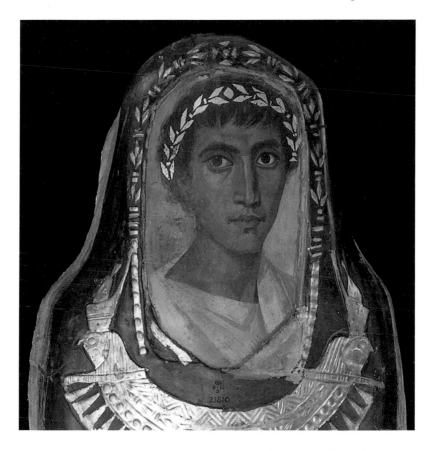

16, 17. *A strikingly naturalistic image of Artemidoros is set above the schematic scenes of funerary myth and mummification (left). It surely hints at the living appearance of the young man and trades on the idea of individual likeness – though quite how 'realistic' it was we cannot, of course, know.*

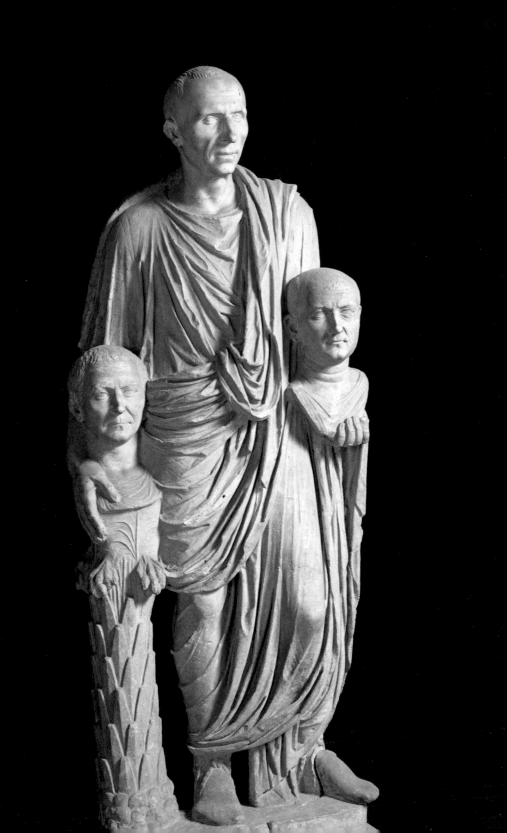

processions of the elite featured family members who wore masks representing the ancestors of the deceased (as well as dressing in the distinctive costume of each one), and the central hall of rich Roman houses was almost a gallery of the images of dead forebears. In fact, when Romans thought about where the impulse to portraiture came from, one of the stories they told was a story of loss: not in this case of death but of poignant absence of another kind.

It is a story that has come down to us because it was included in a vast encyclopaedia compiled by the obsessive Roman polymath, Pliny 'the Elder' (so called to distinguish him from 'the Younger'), who died in 79 CE, trying to get too close to the eruption of Vesuvius that destroyed, and preserved, Pompeii. In his discussion of the origins of different forms of art, he gave a starring role to a young woman who was the creative genius behind one of the earliest portraits. Her lover, it was said, was going away on a long journey and, before he went, she got a lamp, threw his shadow against the wall and traced round it to create his silhouette. There are all kinds of complexities to this tale. Where or when the story began, we do not know (it

18. An early first-century CE marble statue from Rome, showing a man carrying two portrait heads, perhaps of his ancestors. The identity of the figure is unknown (there are any number of theories, and head is a later replacement anyway); but it captures the central role of portraiture in the culture of the Roman elite.

is actually set in the early Greek city of Corinth); and despite the leading role of the young woman, she remains anonymous, known only by the name of her father as 'Boutades' daughter'. He was a potter who went on to construct a permanent ceramic version of the man from the silhouette – which was said to be the very first 3-D, modelled portrait ever made. But whatever its precise background, in telling this story, some Romans at least were imagining that portraiture from its very origin was not just a way of remembering or memorialising a person, but a way of actually keeping their presence in our world.

Something much like that is going on with the face of Artemidoros. Marks of domestic wear and tear on some of these coffins, even occasionally some children's scribbling, suggest that for a while at least they stood in the land of the living. Before eventually being buried in the ground, they had a place perhaps in the family home. These portraits, then, were not just memorials. They were attempts to keep the dead present among the living and to blur the boundary between this world and the next.

19. *The story of Boutades' daughter became a favourite with later artists, who saw in it a powerful founding legend. In 1793, the Flemish painter, Joseph-Benoît Suvée re-invented the moment when the young woman drew the silhouette, in a way that combines artistic creativity with lovers' embrace.*

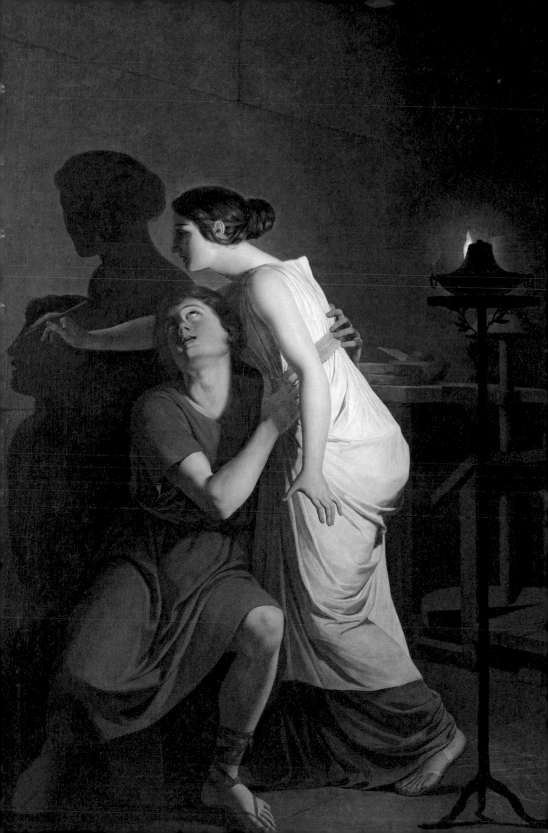

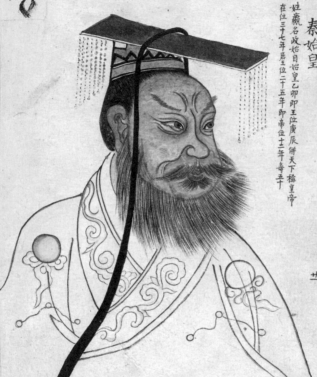

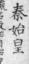

진시황

秦始皇

姓嬴名政始目始皇乙卯卽王位庚辰併天下稱皇帝
在位三十七年居王位二十五年卽帝位十二年壽五十

廿

THE EMPEROR OF CHINA AND THE POWER OF IMAGES

There have always been some images, however, not designed to be seen at all. If painted faces and sculpted bodies played a vital role in the lives of those who lived with them and looked at them, how do we understand the role of images that remained forever invisible to the human eye, even though an enormous amount of time, money, effort and skill was expended in producing them? That is one question raised by the greatest and most surprising archaeological discoveries of the twentieth century, made in Shaanxi province in central China in the 1970s: the hundreds of 'terracotta warriors' unearthed from the tomb of Qin Shihuangdi, the first emperor of China. The whole complex adds up to the biggest tableau of sculpture made anywhere on our planet, ever.

20. A nineteenth-century Korean re-imagining of the first emperor of China. No portraits from his lifetime survive.

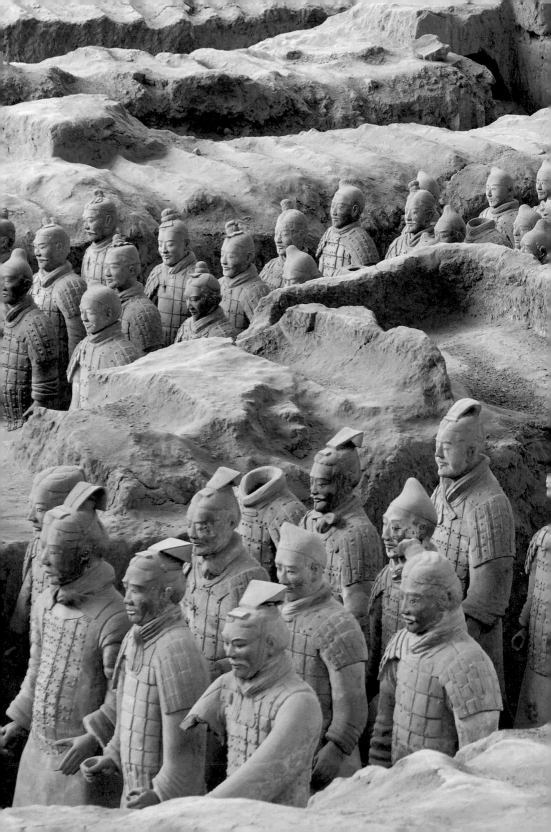

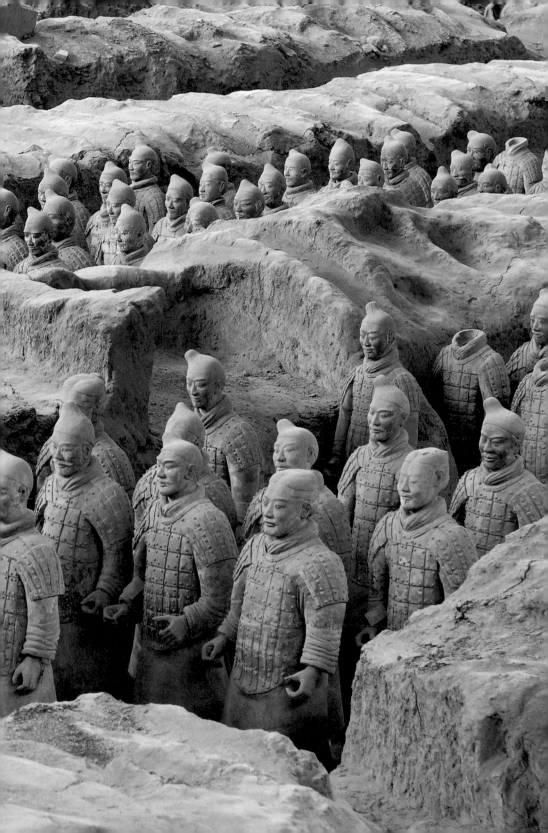

Qin ruled in the late third century BCE, and was in many ways the creator of modern China, uniting its territory, standardising currency and weights, developing roads and transport, imposing taxation and marshalling huge military force. There is a striking resemblance with what was happening at roughly the same time on the other side of the world, in the growth of Roman imperial power. Some 200 years after the reign of the first emperor, it is reckoned that half the earth's population lived under the control of either Rome or China, and there are reports of a few puzzled ambassadors travelling between the two capitals (not to mention all kinds of tall stories: Roman writers imagined the Chinese lived to the age of 200; Chinese writers in their turn claimed that Romans rulers lived in palaces with columns made of crystal and that the people were expert jugglers). But no Roman emperor was ever buried on the grand scale of Qin. The emperor Augustus in the first century CE and Hadrian in the second century had large mausolea, which are still landmarks in the city of Rome (in the Middle Ages both were turned into fortified castles, and Augustus' later still into an opera house). But they are modest in comparison with Qin's tomb.

21. One of the 'pits' of the tomb of the first emperor, with the massed ranks of warriors standing guard.

What has been discovered of Qin's tomb is a menacing sight: rows and rows of soldiers in terracotta, once brightly painted, now the grey ghostly remnants of an army. They represent the Imperial Guard of the emperor, buried with him at his funeral to stand in watch, we may imagine, over his remains. Only a fraction of the original 7,000 or so have yet been excavated from a series of pits at least a mile away from where the emperor's body lay, still undisturbed by archaeology (partly because Chinese archaeologists have the good sense to realise that the centre of the complex is best preserved where it is, underground). The size of this installation is still extraordinary, the detail of the figures too. You can see the individual plates and rivets of the armour, and the heads are modelled so that no two are exactly the same. There are droopy moustaches and straight ones, elaborate top-knots and close crops, the contours of their faces differ – not to mention their different styles of shoes and boots, and different armour for the various ranks of soldier.

This striking individuality is not quite so simple as it seems at first glance. It is true that every single one appears to be different, but the differences that the craftsmen have introduced turn out to be formulaic. The soldiers themselves are made in pieces, with the head slotted in last, and the variety in the facial features is the result of mixing a fairly restricted repertoire of elements: there are only

a few different eyebrow types, for example, or different moustache types, put together in different combinations. They are not 'portraits' in the way that we conventionally use the word. As one archaeologist has nicely put it, their faces *are* likenesses, but they are likenesses of no one. For me, to play with a different paradox, they suggest a highly

22. *The individuality of the warriors and the details of the armour, right down to the individual rivets, are at first sight striking. But they are less 'individual' than they appear: they are made up of a few standardised elements, combined in different ways.*

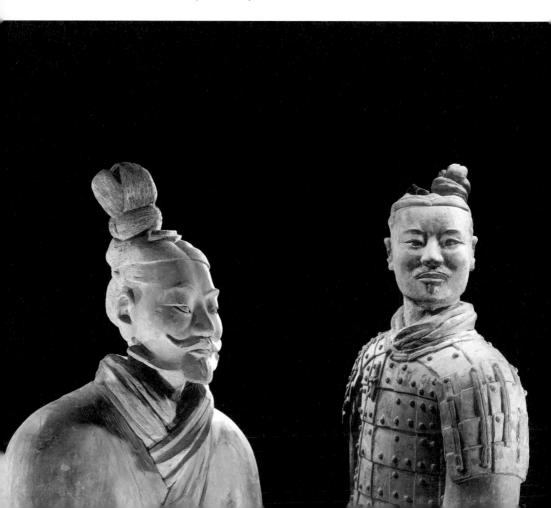

standardised version of individuality. In other words, they offer a challenge to any simple notion of a true portrait, pointing to other versions of what a 'likeness' might be.

There have been all kinds of explanations of what these images were *for* – ranging from the idea that they were made as substitutes for the human victims who in a more brutal age would have been sacrificed at the emperor's funeral, to the claim that they are not actually *representations* in our terms at all, but should be seen as a real army defending the emperor in that parallel, invisible but still real world

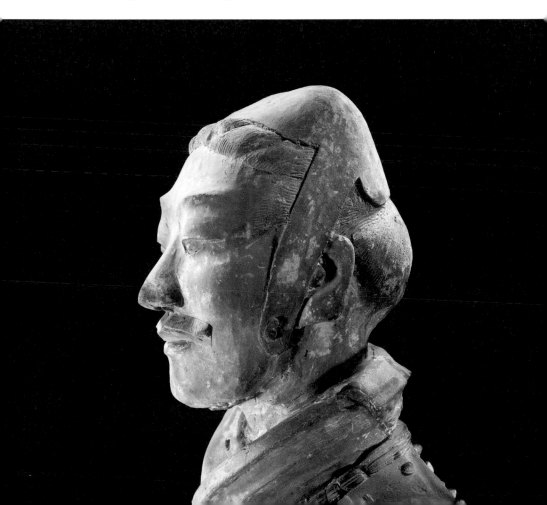

inhabited by the dead. But all that is mostly guesswork. Only one thing is for sure: in the scale and complexity of the tomb, and in all the artistic detail, that the emperor dead or alive could command, there is a strong assertion of imperial power. And that assertion is made even stronger by the fact that all this effort had gone into producing what was planned never to be looked at again.

That might almost have been the case. But long before the soldiers were uncovered by archaeologists, just a few years after the emperor was buried, in a much less known aspect of this tomb's story, a considerable part of the army was destroyed. When we look at these figures now, what we are actually witnessing is a triumph of archaeological reconstruction as much as discovery. For many of these soldiers were found in pieces. They were not dilapidated through natural wear and tear but, soon after the first emperor's death, they were smashed and burned by rebels against the dynasty who launched a direct attack on his burial place. In that keen desire to destroy them lies the clearest sense of the power of these images.

SUPERSIZING A PHARAOH

S tatues and paintings were also important ways in which, hundreds of years before the first emperor, Egyptian pharaohs asserted their own power after death. Those vast figures, which Hadrian and his contemporaries believed to represent the hero Memnon, had actually been created as images of the Pharaoh Amenhotep III, to stand outside his tomb, as reminders of his sovereignty. But in ancient Egypt it was as much power in the here and now that was expressed by images in huge quantities and on a massive scale. No living pharaoh invested more in the production of his own image than Rameses II, who was born about 1300 BCE, just over a century after Amenhotep's birth. It is one of the most famous cases in the ancient world – or even still in the modern – of an autocrat trying to assert his claim to power through images of himself. In the process he posed

23. A nineteenth-century photograph of the Ramesseum, with four figures of the god Osiris making a divine façade.

61

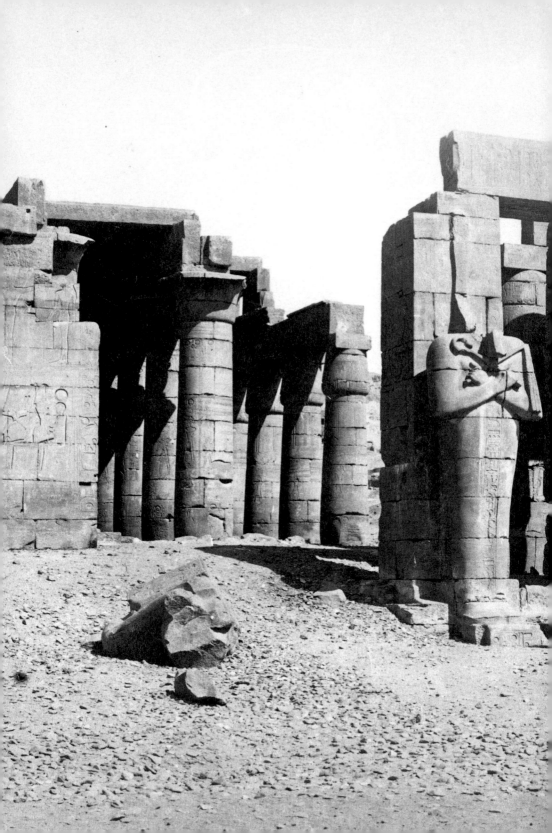

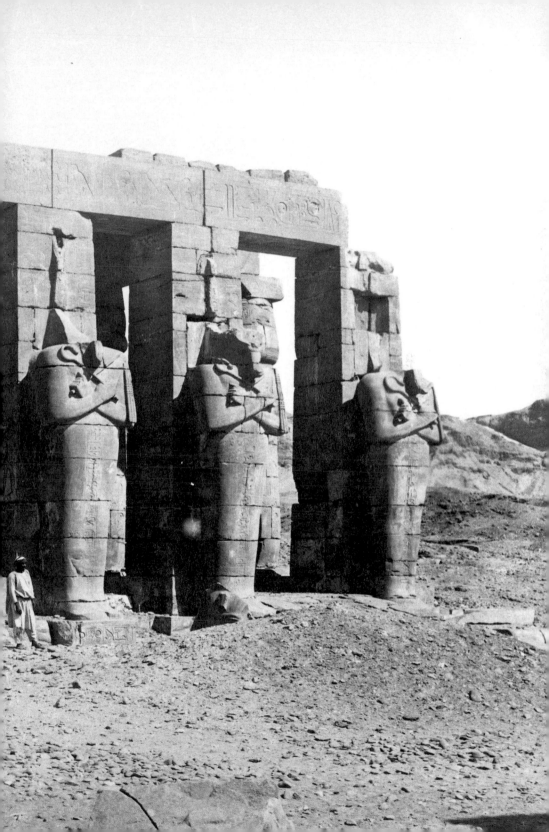

important questions for us about how viewers reacted to these statues and who exactly those viewers were.

One place he displayed his image was the tomb and temple – the so-called Ramesseum – erected on the banks of the Nile during his lifetime, a real image factory. Its walls were covered with carvings of the victorious pharaoh in action, and its courtyards are still littered with images of him. There are scenes of battles in which the ruler is larger than anyone else, trampling on his tiny enemies, even in battles that we know to have been, at best, no-score draws. And it was written reports of Rameses' temple and of the remains of his sculptures that in the early nineteenth century inspired the poet Shelley (he had not actually been there) to reflect on the transient power of autocrats in one of the best half-remembered poems of the English language, 'Ozymandias' (the Greek version of the name Rameses). 'Two vast and trunkless legs of stone / Stand in the desert ...' he wrote; and nearby, he claimed, was a famous inscription, 'My name is Ozymandias, King of Kings. / Look on my Works, ye Mighty, and despair!'

Shelley's point was that, whatever the proud boasts of Rameses, his power had eventually faded; and so, in a way,

24. *The outer wall of the temple at Luxor is dominated by vast seated statues of the pharaoh – whether such oversizing is a mark of self-confidence or anxiety is a tricky question.*

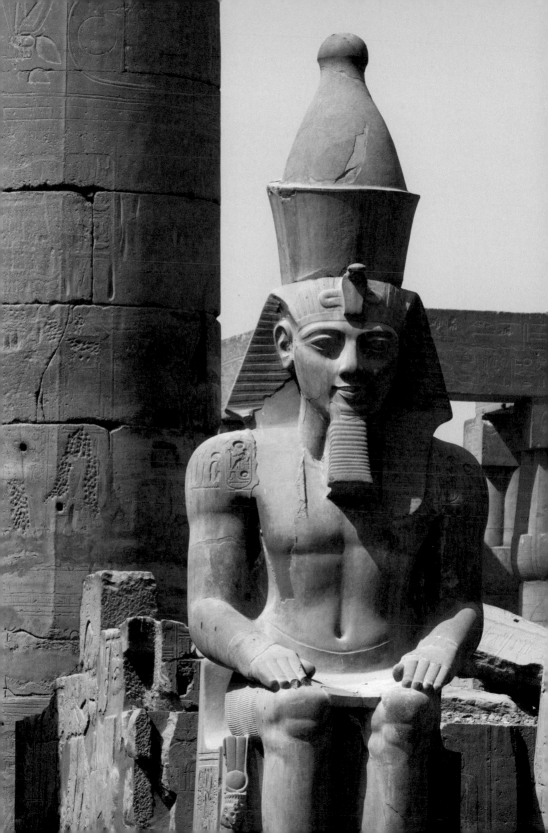

it has. But, as the poem itself shows, statues (and ironically the poem too) gave Rameses a lasting celebrity, not only in this Ramesseum but also in an earlier temple a few miles away, which he renovated and embellished with images of himself and is now one of the famous tourist sights of modern Luxor. At its front door sat two colossal figures of the pharaoh, four or five times life-size, reminding us just how much size can matter. They dominate our field of vision, with a nice hint that they would be even bigger if only they could be bothered to stand up for us. They are an image of the monumentality and permanence of the Egyptian ruler that the modern world has comprehensively accepted – however fragile, messy or frankly inefficient the

25. The diminutive size of my own human figure, against the statue, makes a clear point. But the message of power here was surely as much for the human-sized pharaoh himself, as for the Egyptian people in general.

power of this or any other pharaoh might have been in real life (we tend to give past empires, and even modern ones, far too much credit for the effective use of power). When people walked past this Luxor temple 3,500 years ago, they would surely have seen what the message was.

But, as with all such apparent 'propaganda', there are different sides to this. For a start, the bombastic bare-chested display of these figures is the kind of thing that we now tend to ridicule when we see it used by modern autocrats. The more power flaunts itself in your face, the more it risks undermining its claims to be taken seriously. Ancient viewers were not all naïve consumers of any message that was thrown at them. Even if some would have looked on these statues in awe and wonderment, it is a fair guess that others would have walked by and laughed, or even spat. In the end, images of power are only as powerful as those who view them allow them to be. And what viewers are we talking about?

Any Egyptian man or woman in the street, rich or poor, slave or free, could have seen these colossal pharaohs sitting at the temple façade. But deep inside the temple – in areas that would not have been accessible to the general public, but only to priests and those in the court circle – were many more images of Rameses, on a similarly colossal scale. Who were these aimed at? Some people have suggested that they were a message about pharaonic power intended for the

religious and political elite who were allowed into these spaces, to remind them who was boss; for the biggest threat to any ruler always comes from those closest to him. Others have tried to rationalise them by claiming that they were created with no human viewer in mind, but principally for the eye of the gods. But one of the most important viewers is often forgotten.

That is the pharaoh himself. Those of us with no inkling of power on a grand scale often forget how hard it must be to believe in oneself as monarch or autocrat. The person who really needs to be convinced that he or she is preeminent, above the common herd, is none other than the ordinary human being who is masquerading as omnipotent ruler. That is why, as a basic rule, we find more images of kings and queens in all their finery in royal palaces than anywhere else; and it is why, for example, some of the most famous images of Roman emperors have been found on properties almost certainly owned by the imperial family. In Egypt too, monumental images of pharaohs commissioned by pharaohs themselves in vast numbers played their part in convincing the pharaoh of his own pharaonic power. It makes a nice twist on the usual idea of 'propaganda' to think that at least one target audience of these colossal images of 'the-body-as-power' was the person who had commissioned them.

THE GREEK REVOLUTION

In the history of the art of the body, images like those of Rameses II have another, very different legacy beyond their assertion of power down the centuries. Egyptian sculpture in this style – whether of pharaohs on that vast pharaonic scale or more modest images of a whole range of subjects – most likely lies behind the beginnings of monumental human sculpture in ancient Greece. Images of the human body in marble, life-size and larger, appeared very suddenly in the Greek world in the seventh century BCE and it is impossible to know for certain how that tradition arose, and why so quickly and apparently fully formed. There had been small-scale sculpture in Greece before, including a notable series of prehistoric human figurines stretching back to at least 3000 BCE, but nothing like what we find in this later period. The most plausible explanation is that Greek sculptors adopted and adapted what they had seen in Egypt and in their interaction with Egyptian artists. There are, it is true, some differences between Egyptian and early Greek sculptures. Egyptian versions of the male human figure

are always partially if scantily clothed, while Greek male statues are regularly shown naked; and other, near Eastern, influences have sometimes been thought to be at work too (some details, such as the female hairstyles, seem closer to earlier small-scale representations from Syria). But the overall similarity in the stance of these vast stone men, one leg standing stiff in front of the other, is very hard to explain without imagining some direct contact and inspiration.

Most of these early Greek figures, the static men in marble and the sometimes plank-like women, now stand

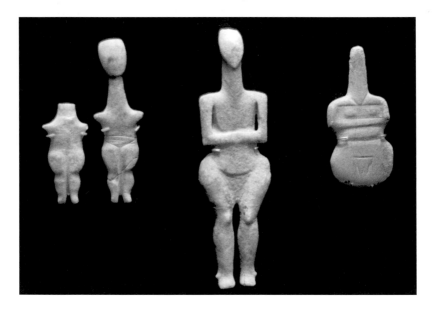

26. *There was an ancient tradition in Greece, from at least the third millennium* BCE, *of prehistoric figurines ('Cycladic' figurines, so-called after the Cyclades islands). But there appears to have been a complete break between these and the earliest 'classical' art in the region.*

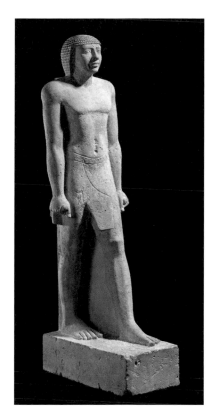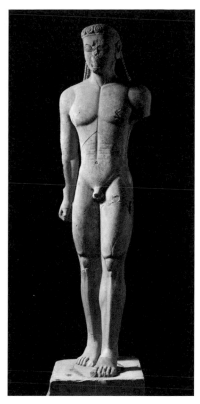

*27, 28. These images – Egyptian on the left, early Greek on the right –
show the similarities between the two traditions of sculpture (the stance,
the clenched fists). But there are important differences too. Notably, the
Greek male statues are almost always naked, unlike the Egyptian.*

inside museums, making it easy to forget that the majority
were originally designed for the outside world, whether
as grave markers (like Phrasikleia) or offerings at religious
sanctuaries. But on the Greek island of Naxos one still
remains outside, lying down half-finished in the quarry

where it was being made probably in the late seventh century BCE.

Naxos was famous for its grey-blue marble. With its coarse grain, it was easy to quarry and easy to work, and figures carved from it were shipped all around the Greek world. This one – now known, from the village near which it lies, as the 'Colossus of Apollonas' – never made it off the island. If it had ever been finished, at over thirty feet high, it would have been the tallest ancient Greek sculpture to survive. But something must have gone wrong: perhaps a crack in the marble, perhaps an argument about the contract, or maybe the sculptors had simply overreached themselves with this vast size. Like all such half-finished pieces (Michelangelo's 'Prisoners' are perhaps the most famous examples), there is something strangely appealing, as well as slightly unnerving, about this human figure that has only partly emerged from the natural rock and has been stopped in his tracks ('so stubborn he hasn't budged in 2,500 years', one is tempted to say). We can just detect those legs frozen as they were beginning to stand in the characteristic pose, and it seems that this figure was, unusually, going to have a beard. But this 'Colossus' also gives us a glimpse into

29. The unfinished statue still lies in the pit carved out for it when it was first made. It has been a local landmark and meeting place on Naxos for centuries, and is one of the few ancient Greek statues in the world on which visitors are welcome to climb and sit.

how these early Greek sculptors went about their work, and the number of people that must have been involved in the whole process, for maybe months at a time. Every one of the little pockmarks still visible in the marble is the trace of the pick or the chisel of one of a workforce of dozens or perhaps hundreds. Just as many would have been needed to haul the statue (probably still waiting for the finishing

30, 31, 32, 33. These four images sum up the Greek Revolution. On the left the stiff, almost plank-like style of the sixth century BCE, *compared with the subtle modelling and movement of the fifth-century sculptures on the right.*

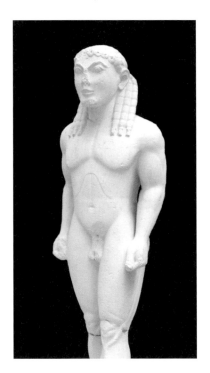
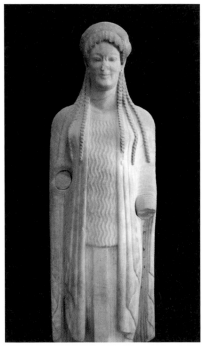

touches to be completed at its final destination) down from the quarry high up on the hillside, and into a boat.

But that is only the start of the story of Greek sculpture. This so-called 'archaic' style of representing the human was soon displaced. Between the sixth and fifth centuries BCE the rigid figures of the past gave way to daring experiments in form. Sculptures appear to spring to life, to move, to dance, to throw spears, to hurl discuses. They hint in an entirely new way at the muscles beneath the surface of the skin, or even – in the case of the heavily clad women – at the limbs, breasts and body beneath the rippling drapery.

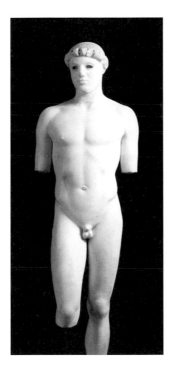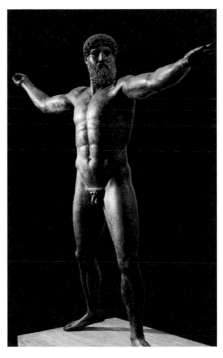

So dramatic and so swift was this change that it is often now called 'the Greek Revolution' and the causes of it are one of the biggest mysteries in the whole history of art. All kinds of theories have been proposed, and some very different ideas about how it might be connected to other cultural or political innovations in Greece during this period, whether the beginnings of theatre or the origin of philosophical thinking. But none is really convincing. We certainly cannot point to some individual artistic genius behind the change; the unfinished colossus on Naxos is a forceful reminder that we should think of early Greek artistic production as a communal and social activity. Even so, the communal and social factors that underlay the change remain elusive. Satisfying as some have found it to imagine that early Greek democracy, combined with a new view of 'the individual', somehow kick-started the whole process, the exact chronology does not easily fit (the artistic changes get underway before democracy made much of a showing). Besides, although Athens, with its increasingly radical democratic form of government, was a major centre of the new style, there were many areas in the Greek world deeply opposed to anything resembling of democracy – and they were deeply implicated in these developments too.

What we *can* see much more clearly are the consequences of this 'Revolution' in the art of the Greek and Roman worlds over the next centuries. In this process Romans did

34. *The exhausted Boxer looks away from us. The key to his profession lies in the distinctive boxing gloves on his hands, as much as on his battered body.*

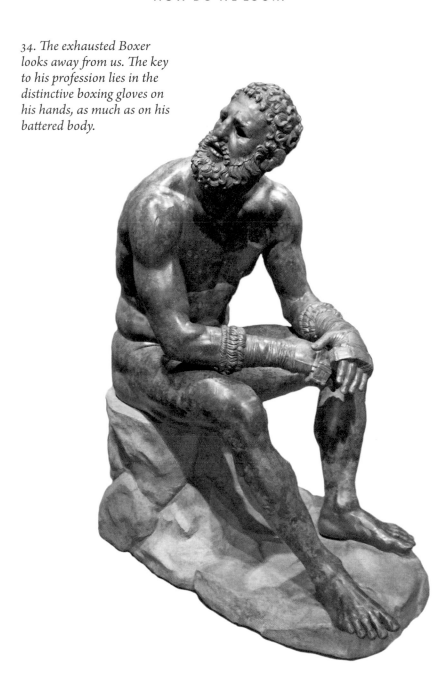

not play the part merely of plunderers or slavish imitators of Greek traditions, as they have often been presented. They were skilled artists and adaptors themselves and were responsible for spreading what became a mixed 'Greco-Roman' artistic style across their empire. The distinctive engagement with the human form that ultimately went back to sixth-century Greece came to be exploited in extraordinary ways, in some of the most admired works of western art ever.

One memorable example of this style is the bronze image of a boxer, discovered in 1885 in the centre of Rome, on the slopes of the Quirinal hill, a short distance from Trajan's column. This was the time when the modern city was being redeveloped on a grand scale as the capital of the united Italy, and when the antiquities found in excavating the foundations of the new housing and administrative buildings were restocking the city's museums (192 marble statues went into one museum alone in the 1870s and 1880s). Even among so many notable discoveries, the excavation of the bronze 'Boxer', in the construction work for a new theatre, created tremendous excitement. An observer who watched it emerging from the ground had

35. *The Boxer's face reveals the wounds he has suffered, in the scars and bleeding gashes under his eyes, carefully rendered in different alloys. His eyes would once have been represented in glass or a different metal.*

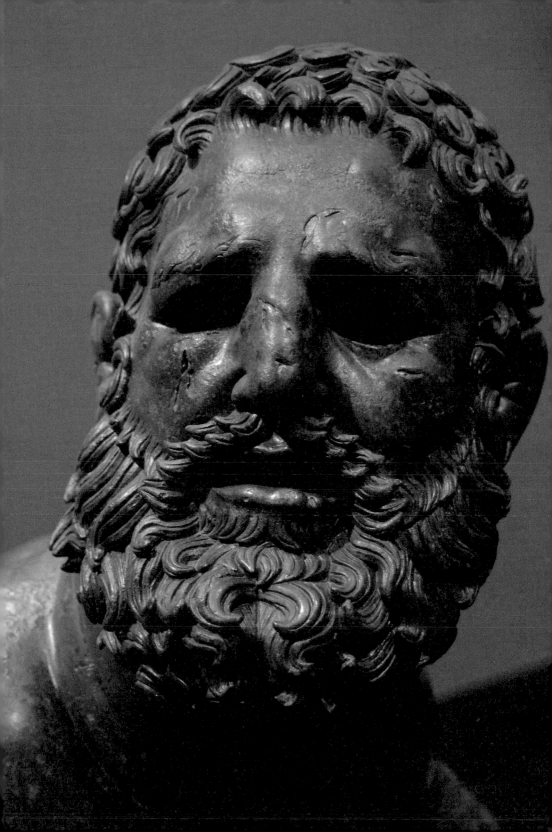

this to say: 'I have, in my long career in the active field of archaeology, witnessed many discoveries ... I've sometimes ... met with real masterpieces, but I have never felt such an

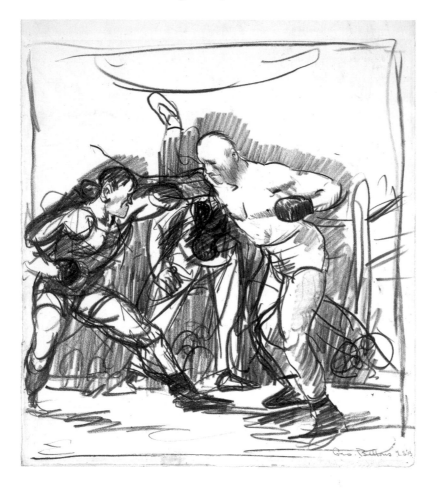

36. *The ancient Boxer in some way prefigures the realist images of boxing in the works of George Bellows in the early twentieth century; here a 1919 drawing by Bellows recognises, and undermines, the glamour of the 'Prize Fight'.*

extraordinary impression as the one created by the sight of this magnificent specimen.'

The early history of this boxer is hard to fathom. Because the processes of their manufacture were so similar over time and across the classical world, it is often difficult to put a precise date on bronze sculptures, or to know exactly where they were made. This piece was found in Rome, but it may have been made in Greece, and it could date to almost any point between the third and first centuries BCE. But whatever its origin, it is not only an astonishing artistic achievement but also a piece of art in which we can see the preoccupations of the Greek Revolution brought together and trained onto the body, not of a youthful and perfectly formed athlete, but of an elderly battered and bruised boxer. Boxing was always an important part of the ancient athletic repertoire, and the conceit of this sculpture is that the man must once have had a fit and toned body – but it has really suffered. The anonymous artist has focused on a wreck of a human being, devoting his skill to a broken nose and cauliflower ears, flabby from all those blows. In fact, he appears to be still bleeding from fresh wounds. The blood is shown in copper and the bruises on his cheeks are brought out by a slightly different colour of a slightly different bronze alloy. It is almost as if the bronze has become the man's skin.

It is easy to take this kind of 'realism' for granted (for we have inherited its conventions), or even to see here some

early version of the kind of social realism that we now associate with early twentieth-century images of boxers. We don't usually think of social realism as being something invented in antiquity, but – in a sense – here it is: not just in the scars and the cuts but in the emotional collapse as this man sits wrapped up in himself. But there is something more to this piece, and it goes beyond the clever artistic technique to an implied critique of some of the ideals of ancient 'body-culture'. In a world in which there was something of a cult of youthful athletic prowess, all those telling realistic details add up to a reminder that the body beautiful was not so very far from the body brutalised. This work of art is prodding at the awkward underbelly of classical culture.

Masterpiece though the Boxer is, it also hints that we should be looking for the complexities of the Greek Revolution, beyond the simple idea of artistic triumph. First, and often forgotten, are the losses it entailed, as well as the gains. No revolution is without its downsides. In this case, a look back to the extraordinary memorial to Phrasikleia, who died unmarried, highlights one of them. She was sculpted before the revolutionary artistic changes. A hundred years later she would not have been shown squeezing her dress as if, in our eyes, it was a lump of plasticine rather than fabric. Her clothing would have fallen in delicate folds, revealing the form of her body beneath,

37. No real fabric ever behaves like this. But this close-up shows clearly the traces of coloured decoration that still remain on the statue.

and she herself would have moved more sinuously than this plank-like stance. But she would not have confronted us as directly as she does, reaching out offering a gift or meeting us eye to eye.

Directness is exactly what gets lost in the Greek Revolution. Later sculptures may be more supple than

Phrasikleia, they may be far more adventurous in their pose. But they do not engage with their viewers like she does. In fact, if you try to look them in the eye many of them coyly avoid your gaze, and many of them, like the Boxer, seem lost in their own world. It is almost as if the involved viewer has become an admiring voyeur and we are one step on the way to sculpture becoming an art object. Phrasikleia is determinedly resisting being an art object and one thing she's not is *coy*.

But other complexities emerge when we start to push at the dividing line between human beings and their apparently 'lifelike' representation in bronze and marble. In the Greco-Roman imagination there was a blurry and perilous boundary between artefact and flesh – with particularly unsettling consequences for statues of the female nude, which in another revolutionary development first became part of the repertoire of classical sculpture in the fourth century BCE.

THE STAIN ON THE THIGH

Greek and Roman writers repeatedly explored the idea that the finest form of art was a perfect illusion of reality; or, to put it another way, that it was the pinnacle of artistic achievement that there should be no apparent difference between the image and its prototype. The most famous anecdote along these lines concerned two rival painters of the late fifth century BCE, Zeuxis and Parrhasios, who held a competition to decide which of them was the more skilled. Zeuxis painted a bunch of grapes so realistic that the birds flew in to eat them. It was a triumph of illusion that promised to win the day. Parrhasios, however, painted a curtain – which Zeuxis, flushed with his success, demanded that he draw aside to reveal the painting beneath. According to Pliny, who recounted the incident in his encyclopaedia, Zeuxis quickly realised his mistake and conceded victory, with the words: '*I* deceived only the birds, Parrhasios deceived *me*.'

No trace of any such paintings survives, if they ever existed beyond the anecdote. But we do have evidence for

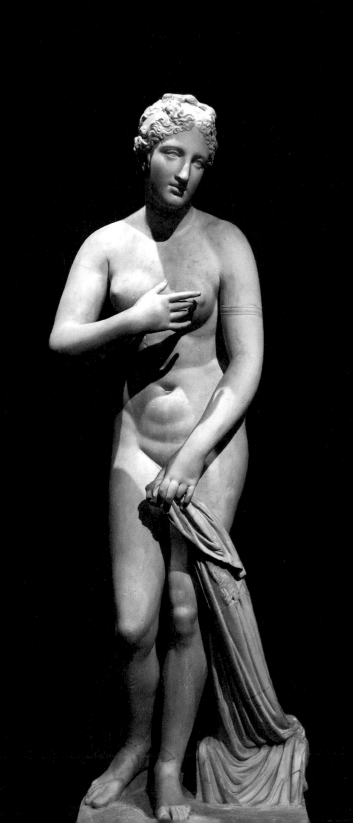

a marble statue that was the subject of a similar – though far more disturbing – story. That is a sculpture made by the artist Praxiteles around 330 BCE – a work now usually known as the 'Aphrodite of Knidos', after the Greek town on the west coast of modern Turkey that was its first home. It was celebrated in the ancient world as a milestone in art, since it was the first full-sized naked statue of a female figure (technically, in this case, a goddess in human form), after centuries in which sculptures of women had, like Phrasikleia, been represented clothed. Praxiteles' original has long been lost; one story is that it was eventually taken to Constantinople, where it was destroyed in a fire in the fifth century CE. But it was so famous that hundreds of versions and replicas of it were made across the ancient world, in full size and miniature, even appearing as the design on coins. Many of these versions have survived.

Today it is difficult to see beyond the ubiquity of such images of the naked female form and to recapture how daring and dangerous it must have been for the original viewers in the fourth century BCE, who were certainly not used to the public display of female flesh (in some parts of the Greek world real-life women, at least among the upper

38. A Roman version of the Aphrodite of Knidos. The drapes falling from her left hand fulfil a double function. They 'excuse' her nakedness (we can imagine that she has just been caught after her bath), and more practically they act as a marble support for the statue.

class, went around veiled). Even the phrase 'first female nude' underplays the impact, by implying that it was an aesthetic or stylistic development somehow waiting to happen. In fact, whatever was driving Praxiteles' experiment (this is another 'Greek Revolution' whose causes we do not fully understand), he was destroying conventional assumptions about art and gender in much the same way as Marcel Duchamp or Tracy Emin have done since: whether that is turning a urinal into an art work in the case of Duchamp, or Emin's tent, entitled *'Everyone I Have Ever Slept With'*. It was perhaps not surprising that the Greek town of Kos, on an island off the Turkish coast – the first client to whom the artist offered his new Aphrodite – said, 'No, thank you' and chose a safely clothed version instead.

But simple nakedness was only part of it. This Aphrodite was different, in a decidedly erotic way. The hands alone are a giveaway here. Are they modestly trying to cover her up? Are they pointing in the direction of what the viewer wants to see most? Or are they simply a tease? Whatever the answer, Praxiteles has established that edgy relationship between a statue of a woman and an assumed male viewer that has never been lost from the history of European art – as some ancient Greek viewers themselves were all too well aware. For it was an aspect of the sculpture dramatised in a memorable tale of a man who treated this famous goddess in marble as if she were a woman in flesh and blood. It is

told in its fullest form in a curious essay written around 300 CE.

The writer reports what is almost certainly an imaginary argument among three men – a celibate, a heterosexual and a homosexual – who are having a long and tricky discussion about which kind of sex, if any, is best. In the course of this they arrive at Knidos and make for the biggest attraction in town, which is the famous statue of Aphrodite in her temple. While the heterosexual is leering at her face and front, and the man who prefers the love of boys is peering at her backside, they spot a little mark in the marble at the top of the statue's thigh, on the inside near her buttocks.

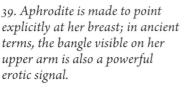

39. *Aphrodite is made to point explicitly at her breast; in ancient terms, the bangle visible on her upper arm is also a powerful erotic signal.*

As something of an art connoisseur, the celibate starts to sing the praises of Praxiteles who had managed to hide what must have been a blemish in the marble in such an inconspicuous place – but the lady custodian of the temple interrupts him to say that something much more sinister lay behind the mark. She explains that a young man had once fallen passionately in love with the statue and managed to get locked in with her all night; and that the little stain is the only surviving trace of his lust. The heterosexual and the homosexual both gleefully claim that this proves their point (the one observing that even a woman in stone could arouse passion, the other that the location of the stain shows that she had been taken from behind, like a boy). But the custodian insists on the tragic sequel: the young man went mad and threw himself off a cliff.

There are several uncomfortable lessons inscribed in this story. It is a reminder of how troubling some of the implications of the Greek Revolution could be, how seductive to blur the boundary between life-like marble and real-life flesh, and at the same time how dangerous and foolish. It shows how a female statue can drive a man mad but also how art can act as an alibi for what was – let's face it – rape. Don't forget, Aphrodite never consented.

THE REVOLUTION'S LEGACY

There is an even more influential – and sometimes darker – legacy of the Greek Revolution and its distinctive rendering of the human body, which still remains with us in the West, even if we can often be blind to it. The influence of the ancient world is not something that is stuck safely in the remote past: what we would now call the 'classical style' has a long and powerful history right up to the present day. Since the European Renaissance from the fourteenth century on, it has been constantly re-negotiated, re-appropriated and invested with ever greater meaning. Seen not merely as a model for figurative art to aspire to (or for radical artists to overthrow), it has been turned in some contexts almost into a barometer of one version of civilisation itself.

To understand the forces at work behind this, we have to follow in the footsteps of the classical bodies that left their original habitat of Greece and Rome and by the eighteenth century had found themselves in distinctly foreign worlds, adorning the mansions and palaces of northern Europe.

One very special place that brings this story to life is Syon House, just outside London, once the fashionable country seat of the first Duke and Duchess of Northumberland. It was transformed in the mid-1700s into a vivid re-expression of the classical world.

One of those behind the design was the Duchess, the clever and enterprising Elizabeth Percy. Most likely, it was she who – along with her architects, the Adam brothers – put together an extraordinary Greco-Roman kaleidoscope of images, icons and bodies that still largely remains there. Using a whole web of agents and dealers and fixers, they acquired some original works of art from Italy, some exact plaster copies, and reliefs and paintings imitating other ancient masterpieces. It can now seem all a bit over the top, upmarket bling, commissioned by the eighteenth-century super rich, determined to parade the greatest hits of classical art, the most expensive wallpaper that money could buy. But it is not quite so simple.

These images at Syon are being used much more constructively. For a start, the portraits of eighteenth-century gentlemen, dressed in their look-alike Roman togas, encourage us to collapse the distance between the ancient and the modern world, and to see a connection between ancient and modern virtue. But the whole layout of the main hall takes that further. At the time of its design there were all kinds of discussions about what statues to have, about

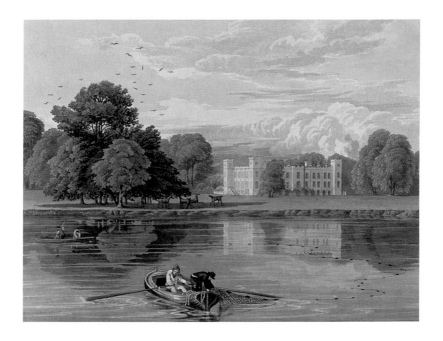

40. An early nineteenth-century view of Syon House; the picturesque landscape, complete with a rustic rowing boat, contrasts with the classical highlights within.

what should go where, and there were various changes of plan. But what they ended up with is a telling sculptural confrontation, where in the main set-piece in the grand hall of the house two great masterpieces of ancient sculpture face off, holding up different mirrors of masculinity and the male body to the men who looked at them. At one end there was a replica of what we call 'The Dying Gaul', a conquered barbarian (but what people in the eighteenth century saw as a dying gladiator), a proud muscular frame in glorious

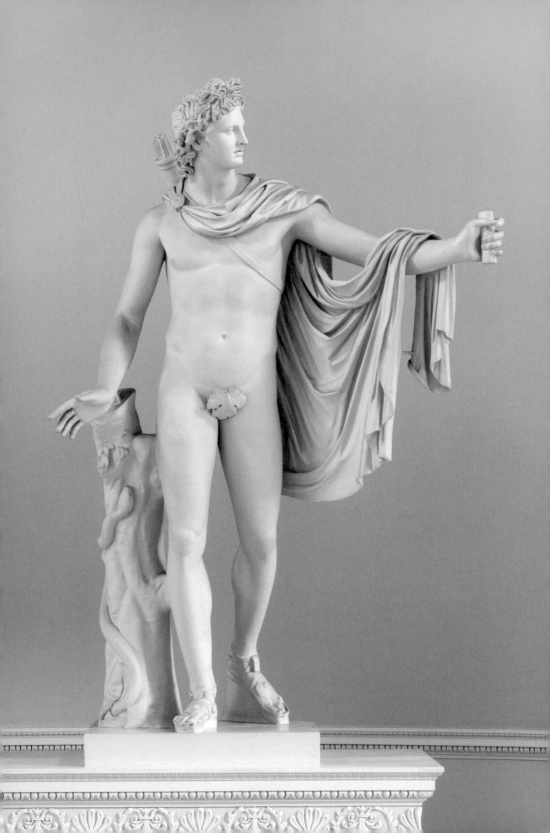

defeat. But he was forever overshadowed by the contrasting image that stands at the other end of the room. That was the slightly eerie version of manhood represented by a replica of the so-called 'Apollo Belvedere'. The date of this statue has always been debated, and it is work that can stand as a symbol of the 'Greco-Roman' style. Is it a Greek work of around 300 BCE? Or is it a much later Roman 'copy' of that? Or is it an original Roman work of art? Whatever the right answer, it was the most renowned work of art in the western world in the eighteenth century.

The Apollo takes his name from the Belvedere Sculpture Court in the Vatican where since the early sixteenth century he stood on display. What was often admired about him was the way the sculptor had captured that moment of rest after the god has just shot his arrows, the muscles now relaxed: a combination of power, majesty and repose. But lovely as he is, the Belvedere Court is probably where he would have stayed, one sculpture among many, had it not been for the international fame given to him by one man: Johann Joachim Winckelmann. He was born in 1717, the son of a German shoemaker, and was murdered fifty years later, in Trieste, at the hands of someone we would be

41. *The plaster cast of the Apollo Belvedere dominates the Great Hall at Syon. We must imagine him as just having shot his arrows – and now about to rest.*

tempted to call a rent-boy. In between he worked his way up as librarian and right-hand-man to some of the biggest art collectors of the day, and finally he had become director of antiquities at the Vatican itself, and the author of some of the most important books on art history ever. Of the Apollo he wrote, 'This was quite simply the most sublime statue of antiquity to have escaped destruction. An eternal springtime,' he went on, 'clothes the alluring vitality of his mature years with a pleasing youth, and plays with soft tenderness upon the lofty structure of his limbs. How is it possible', he asked, 'to describe it?' He was a man who had enthused over any number of Greco-Roman bodies, but the Apollo Belvedere really tipped him over the edge.

The swooning may put us off but Winckelmann offered more than words of adoration. The Apollo was embedded in his brand new theory that leaves its lasting and sometimes awkward legacy. In the library at Syon, as in many of the old libraries of Europe, is the book in which Winckelmann first laid out this framework. First published in 1764, *The History of the Art of the Ancient World* elevated the Apollo above a mere artwork to stand almost as the ultimate symbol of civilisation itself (on the front page it is shown paired, appropriately enough, with the Dying Gaul). In putting the Apollo at the very pinnacle of classical art – though he did not know, any more than we do, what its exact date was – he attempted to argue more systematically than anyone had

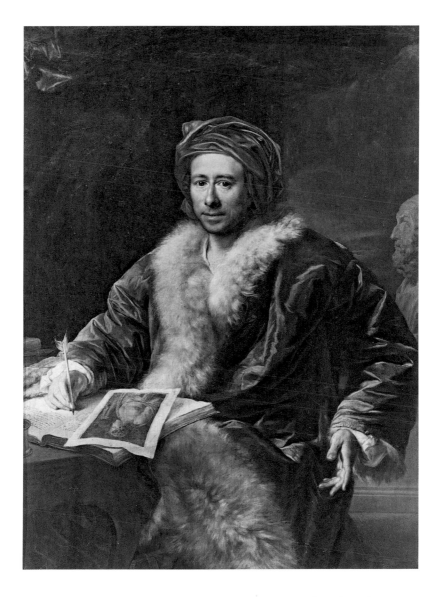

42. *Portrait of J. J. Winckelmann by Anton von Maron (1767). In front of him is an engraving of a marble relief of Antinous (Fig. 4), another of Winckelmann's favourites.*

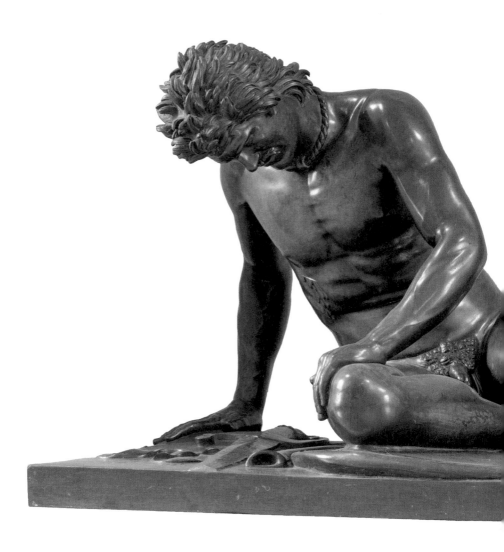

43. The bronze version of the Dying Gaul from Syon House, a symbol of bravery in the face of defeat. The torque (or band) around his neck is a clear indication that he was originally intended to be a Gaul, not, as many thought in the eighteenth century, a gladiator.

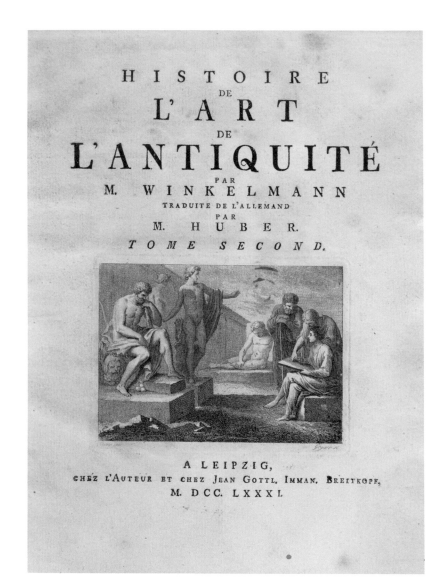

HISTOIRE
DE
L'ART
DE
L'ANTIQUITÉ
PAR
M. WINKELMANN
TRADUITE DE L'ALLEMAND
PAR
M. HUBER.
TOME SECOND.

A LEIPZIG,
CHEZ L'AUTEUR ET CHEZ JEAN GOTTL. IMMAN. BREITKOPF,
M. DCC. LXXXI.

44. *The frontispiece of Winckelmann's History of Art. In this later eighteenth-century reprint the Apollo and the Gaul continue to symbolise the history and 'civilised' values that the book espouses.*

done before that there was an integral connection between art and politics: the *best art*, he insisted, was made at the time of the *best politics*. To put that another way, it is almost as if he was arguing that you could trace the history, the rise and the fall of civilisation, through the rise and fall of the representation of the human body. The Apollo was at the top.

Winckelmann's arguments – radical and, of course, deeply loaded as his theorising was – have been enormously influential ever since in how western viewers have seen and judged art, and particularly the art of the human body. Winckelmann never went to Greece, he admired Greek classical art without ever seeing it, he struggled like us to work out when exactly the Apollo Belvedere was sculpted, and what the difference was between Greek and Roman art. He has often been attacked as a weight of conservatism lying heavy on the history of art, but his views have underpinned some of the most popular and influential interpretations of western art, with an insistence on this particular classical form and style. Perhaps not surprisingly, Kenneth Clark reinforced that view when he was making *Civilisation* in the late 1960s. Even though that series did not specifically cover the art of the ancient world, Clark visited the Apollo Belvedere and spoke of it in terms that were not far short of the extravagance of Winckelmann. 'This is the figure that was the most admired piece of sculpture in the world.

The Apollo surely embodies a higher state of civilisation ... The northern imagination takes shape in an image of fear and darkness. The Hellenistic imagination in an image of harmonised proportion and human reason.' Greek sculpture of the body, as it emerged from the 'Greek Revolution', was well established as a beacon of western civilisation.

But Winckelmann's legacy runs deeper. Even if we are often unaware of its effects, the inheritance of Winckelmann continues to offer western viewers a ready-made standard against which to judge the art of other cultures – sometimes a distorting and divisive lens that is hard to escape. There is one place where we can see this very clearly, and that is back where we started, with the art of the Olmec, and with a surprising twist.

THE OLMEC WRESTLER

It was 1964 and the Mexican government was heavily investing in a national identity that proclaimed the glories of its ancient past, and central to the project was art. A new museum in Mexico City was purpose-built to showcase the depth of Mexican history and the treasures of its great civilisations are still laid out there for all to see. Mexico's earliest civilisation – the Olmec – obviously has a special place. Sharing the gallery with one of the colossal heads is an extraordinary array of other Olmec bodies on a much smaller scale, from a group of exquisite jade and greenstone figurines to a tiny clay model holding an obsidian mirror against its chest (religious symbolism or prehistoric vanity?) and a whole collection of statuettes which look to *us* like babies, though the Olmec may have seen them differently. But of special significance has always been a brand new purchase of the 1960s, a statue now known as 'The Olmec Wrestler'. Nothing quite like it had been known before in Olmec art, with its apparently natural muscles, 'realistic' face and dynamic pose. For many, the

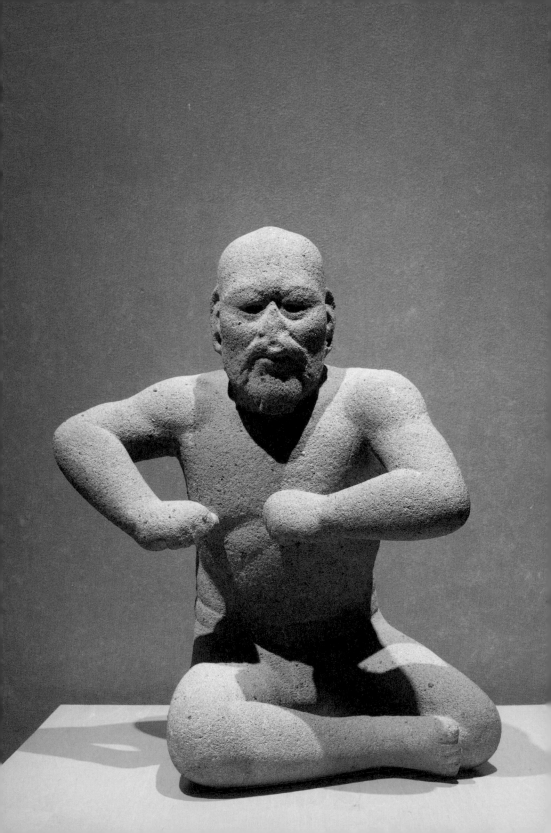

Wrestler was proof that Olmec civilisation was every bit as sophisticated as any in the classical world; he quickly became the poster boy not just for the Olmec but for all ancient Mexico – advertising its culture on countless book jackets.

It is in the celebrity of the Wrestler that we confront some of the consequences of the western way of seeing, and our inheritance of the classical world through the eyes of Winckelmann. Much of what appeals to us about this figure are all those details that seem to match our own long-learned assumptions about what a naturalistic image of the human body should look like. There are even shades of Greco-Roman art in the name we have given to the piece. We have no evidence that he was ever intended to be a wrestler, or for that matter that the Olmec even practised wrestling. But the name is a reassuring echo of classical Greek sport, and its representations. At the very least – modern title aside – if this is the work of an outstanding Olmec sculptor, it is one who by chance got later tastes spot on, hitting on the particular blend that we often look for in the art of other cultures: that it should be sufficiently different from our own to count as foreign, but at the same time fully understandable in our own aesthetic terms.

45. *The Olmec Wrestler has divided opinion: a masterpiece in western terms, or a fake designed to appeal to those western sensibilities?*

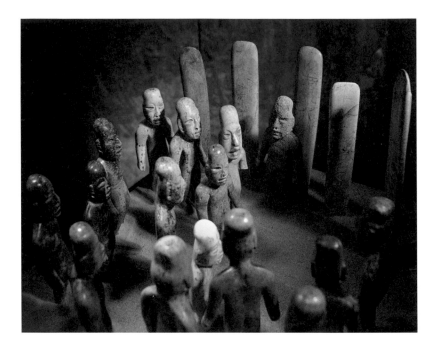

46. This group of figurines was found exactly as they are now displayed in the National Museum in Mexico City, but the meaning is uncertain. Are they a group of priests? Or is it a mythological scene? It is not even clear which are intended to be male and which female.

That is where another side of the Wrestler's story comes in. Nobody has ever managed to pin down where exactly it was found, let alone by whom or how. The basalt from which it is made is not the same variety as that of other Olmec sculptures. And so nicely does it measure up to some western ideals of art that some experts now believe it to be a fake, the work of someone who well understood the allure of the classical style. Fakers, after all, profit from their

47. These 'babies' are a distinctive part of Olmec art. But exactly what they were, and whether they were seen as babies by the Olmec (and if so, why) remains a complete mystery.

ability to produce the kind of art that we want, and they are well aware of the legacy of Winckelmann.

But, genuine or not, the Olmec Wrestler shows that ancient images of human figures can tell us much about the past, and even more about ourselves. When we admire the Olmec Wrestler we are also facing our own assumptions about what makes a satisfying image of a human being; the focus is always partly shifted onto us as viewers and onto our own prejudices. In a way the Wrestler is an acute reminder of one fundamental truth of the art of the body. It is not just about how people in the past chose to represent themselves or what they looked like. It is also about *how we look* – now.

2

THE EYE OF FAITH

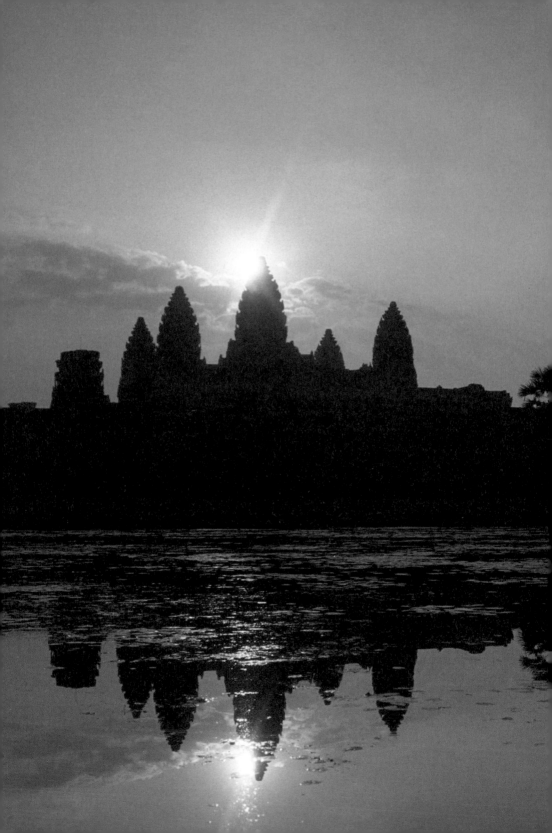

PROLOGUE: SUNRISE AT ANGKOR WAT

Every year thousands of people from across the world come together at a single spot in rural Cambodia to witness an extraordinary sight. At the spring and autumn equinoxes, the sun rises over the central spire at the temple of Angkor Wat, and seems to balance directly on top of it for a second or two. There are almost always gasps of wonderment from the assembled crowd. It is religious art at its most spectacular. In a slightly awkward gesture to the habits of modern pilgrims and tourists alike, the Cambodian government has recently instituted a prize for the best 'selfie' taken on the occasion.

Angkor Wat is one of the biggest and most celebrated religious monuments anywhere, and an expression of royal power like those earlier vast constructions of the Egyptian pharaohs or the first emperor of China. It was built as a Hindu temple by the kings of the Khmer empire

48. The classic equinox view of the sun on the central spire of the temple of Angkor Wat, and reflected in the water.

in the twelfth century CE, though within a hundred years converted into a Buddhist shrine, as their successors embraced Buddhism. Its spectacle does not stop with the balancing act of the sun. The great towers at the heart of the complex are often said to represent the mythical peaks of Mount Meru, the centre of the Hindu cosmos. The moats around the edge are supposed to mimic the oceans at the end of the world. Religious patterns and symbols adorn the walls, and – as if to complete the extravagant superfluity of it all – a seemingly endless frieze wraps around the temple,

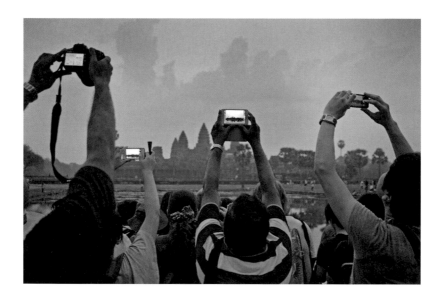

49. It is probably too easy to be sniffy about all the cameras, phones and 'selfies' at sites such as Angkor Wat. There may be a digital surfeit here, but pilgrims and tourists have always wanted to memorialise their visit, and to take home part of the experience.

50. *The frieze around the galleries of the temple extends over almost half a mile, and was once decorated with colour and gilding. This scene is part of a Hindu creation myth, 'The Churning of the Ocean of Milk', which involves gods and demons tugging on the body of a snake – to set the cosmic forces in motion.*

foot after foot of it, mixing scenes of Hindu myth with Khmer royal display.

Some details of the interpretation are far less certain than modern guidebooks like to pretend. And the excess of decoration can occasionally seem exactly that: excessive. But the basic point is clear. The layout of the temple and its sculptures were intended to give concrete form to the claims of Hindu religion and to bring the natural, divine and human worlds into perfect harmony. The alignment of the rising sun and temple spire – carefully contrived by

the architects to make the sun itself a player in this religious drama – is just one of the features of Angkor Wat that reinforced the tenets of Hinduism, and that served to make its religious 'truths' seem true.

Throughout the civilisations of the world, religion and art intersect. Sparks flash between them. The pages that follow are concerned with that intersection, with some of the most dazzling sparks – and with power not merely in the human realm but in the imagined realm of the divine. They are not about any one religion in particular but about religions of all sorts at different periods: from the global to the local; from those with numerous gods to those (in the case of some strands of Buddhism) with no gods in the usual sense of the word at all; from religions long since consigned to history to those that still underpin the modern world. For millennia religion – just as much as the human body – has inspired art; and art has inspired religion, breathing truth into religious claims. It has brought the human and the divine together, and given us some of the most majestic and affecting visual images ever made.

What lies behind these extraordinary creations, and what kind of 'religious work' art does all around the world, are

51. *Angkor Wat from the air. The spires in the centre are surrounded by a series of enclosure walls – it is around the galleries of the outermost of these that the long frieze runs.*

important questions. But the story of religious art is about more than this: it is about human controversy and conflict, peril and risk. Whether we think of Muslims or Christians, Hindus or Jews, there are dilemmas that all religions face when they try to make the other-wordly gods, the saints or the prophets, visible in the here and now. When does the worship of an image turn into dangerous idolatry? Where does glorification of God end and worldly vanity begin? And what actually counts as an image of God, or of God's word? Even the defacement of religious art – 'iconoclasm' – is fraught with problems and paradoxes. Far more than brute vandalism, it may be driven by very different views of what religious art is or should be, and it may indeed reflect an *artfulness* of its own.

Fundamental to all this is the issue of how people look at religious art – or what it is to look 'religiously'. The book ends in what is often thought of as the cradle of western civilisation, the ancient temple known as the Parthenon on the Acropolis of Athens. This brings us face-to-face with the question of what it is we now worship. How far do those who count themselves secular still look with the eye of faith?

WHO'S LOOKING?
'CAVE ART' AT AJANTA

'There are gods, gods everywhere, and nowhere left to put my feet.' Those are the words of the twelfth-century poet and philosopher Basava, as he cast his eyes on the mass of religious images that surrounded him in India. And it is easy to see what he meant. In many parts of the world, religious art is everywhere, not only in shrines, churches or temples. Religion has always brought out the artist in its believers, adorning the body, decorating the home, built into our streets, in both pious and playful ways: from the crosses worn around the necks of Christians to the Hindu gods and goddesses brightly painted on Indian trucks.

The point of all this can seem quite simple, even self-evident – whether we think of these images as a focus of awe and devotion, a reminder of the presence of God, or maybe a way of satisfying our curiosity by taking a peek into

52. *'Gods everywhere' now means a rich tradition in India and Pakistan of gods and other religious symbols displayed on buses and haulage trucks.*

the hidden world of the divine. But, as with the images of human figures in the previous section – the singing statue or the battered boxer – if we go a little deeper and try to explore how these religious images actually work, it turns out to be more complicated than we imagine. Again, a lot depends on the context in which we see them; and a lot depends on *who's looking*. Nowhere are those competing views and viewers clearer than with the early Buddhist

53. The curving rock façade at Ajanta. Begun around 200 BCE, over thirty man-made caves provided prayer halls and accommodation for Buddhist monks.

paintings in the network of monasteries and prayer halls cut into the face of a mountain at Ajanta in north-west India: the Ajanta caves as they are now usually called, begun around 200 BCE, developed in various phases until the end

of the fifth century CE, gradually abandoned, and recently redeveloped as a heritage and tourist site.

There is an often told story of how these caves were first 'rediscovered' in 1819 – or, as western writers have had an awkward habit of saying, 'discovered'. It is one of those *Boys' Own* tales of the British empire, in which a hunting party of young officers came across them by accident while on the chase of a tiger (the leader triumphantly carving his own name, and the date, into one of the paintings: 'John Smith, 28th cavalry, 28 April 1819'). A far more significant story, much less well known, tells of an Edwardian lady, who in the early years of the twentieth century, trekked to Ajanta, loaded down not by rifles and tiger nets but by easels, tracing paper, paintbrushes and pencils. She was Christiana Herringham, artist, suffragist, and a woman who was, to say the least, ambivalent about what the British were doing in India – sometimes thought to be the model for the character of Mrs Moore in E. M. Forster's novel *A Passage to India*, who had her own life-changing experience, and loss of faith, in the (fictional) 'Marabar Caves'. Herringham had been intrigued by reports of an ancient religious site long hidden in the hills and after weeks of rough travel managed to reach it. The paintings, covering many of the caves top to bottom with scenes from the life of the Buddha, were by then in a perilous state. Sponsored by both Indian and British philanthropists (and driven by an extraordinary

54. *Christiana Herringham on her travels. If this looks like a leisured form of transport, her accounts of the work at Ajanta suggest that it was anything but 'leisured'.*

determination), Herringham – along with what was, for the time, an unusually multicultural group of students and artists – set about recording these images before they finally faded away.

The result of this work was published in a single lavish volume, just a few years later, in 1915. It opens with a preliminary series of essays, which make clear how unglamorous the work was. The caves were dark and extremely dirty, home to thousands of bats and nesting bees,

55. *Cave 1 at Ajanta gives a good idea of the decorative profusion inside the caves. Here on the right sits a Bodhisattva, a Buddhist figure of enlightenment and compassion, while to the left and above are illustrations of stories of the previous incarnations of the Buddha.*

56. By isolating tiny vignettes from the caves, Herringham produced a book of extraordinarily attractive images, but of an entirely different character from the originals she was copying.

who did not take kindly to being disturbed by the visiting artists – making their copies onto tracing paper, with as much light as could be thrown from small lamps, often balanced precariously on tall ladders. The essays were followed by what was the real point of the book: the gorgeous colour plates, replicating the paintings in the caves, based on all those careful tracings.

Herringham's mission was to preserve these ancient religious images, part of her wider interests in artistic heritage worldwide (in Britain she was the main founder of the National Art Collections Fund, which still buys works of art for public galleries). But in her mind's eye and on her page, she also radically – and problematically –

re-interpreted these paintings. When she looked at their colour, their perspective, their careful lines and composition, what she saw was the Indian equivalent of Italian Renaissance art; and she sometimes even called the caves a 'picture gallery'. The book was one part of that vision. By taking just the most beautiful vignettes, by filling in the gaps where the paint had flaked off, and by providing pull-outs that you could extract and pin up on your wall, almost as if they were easel paintings, she was translating the images of a Buddhist religious site into the heritage of world art. She certainly recognised the religious purpose of the paintings; in fact, she spent more than fifteen years before her death – from even before her book was published – in private 'asylums', increasingly troubled that she had trespassed on sacred territory. But what really concerned her was the status of this material as Art, with a capital A.

Much religious art is familiar now only in the safe spaces of a gallery. This includes many of those Renaissance paintings that Herringham so admired in the National Gallery or the Uffizi, originally designed for the very different environment of Christian churches. But in order to understand how these images worked *religiously*, we need to imagine them back in their original context. In the case of the paintings at Ajanta, that gives a very different and far more puzzling impression than Herringham's clear and carefully chosen excerpts.

Over and over again the scenes in the caves depict the Buddha as he rejects the vanities of the world, and the trappings of human power, in search of enlightenment. But they are not an easy read. Many of the details must always have been lost in the darkness (the original Buddhist prayer halls were never brightly lit), and they offer a fragmentary and disjointed narrative, which cannot have been easy to follow even for those who knew the stories well. One of the simplest and most appealing examples gives a powerful idea of just how difficult it would have been. It is a painting that occupies a substantial area of one cave wall and illustrates a moral tale about a king of the monkeys, a previous incarnation of the Buddha, who risked his life to save his people. We can make out, for example, the figure of the human king who has declared war on the animals, while his archers take aim at them; we can see the monkey king lying down to bridge a ravine with his own body, so his subjects can make a getaway; and we can spot the human king, curious about this selfless act, having the monkey king taken off to his palace – where the animal proceeds to give a lecture on the responsibilities of monarchy. But it is much harder to decode than that summary makes it sound. For there is no break between any of the scenes, with an apparently undifferentiated mass of figures extending right across the painting. The same characters appear several times over, pictured as they act out their roles at different

stages of the narrative. And the various episodes are not arranged in any obvious logical order (the monkey king's lecture on the duties of a monarch takes place in no obvious sequence, above a window on the upper left). It is about as far from the clear simplicity of Herringham's versions as you could imagine.

This is not simply a muddle. These apparently confusing paintings, created by generations of now anonymous artists, made their viewers *do religious work*. They demanded that those who looked at them – whether monks, pilgrims or travellers – identify, find and re-find the stories of the Buddha for themselves. It was impossible to be a passive consumer of these images; you had to be an active interpreter of them. There was a point too in the fragmentariness of the narration, which in a way echoed the fragmentariness often found in religious stories – their open-endedness, their contradictions and their inconsistencies. Even the lack of light had its part to play. When you came in here with your flickering lamp trying to make out what was on the walls, you were enacting a perfect metaphor for one kind of religious experience: searching for the truth, searching for the faith amid the darkness.

Religion often trades on complexity. Although outside observers and analytic historians may often close their eyes to it, religion exploits the fact that belief can be configured in different ways and that there is always a gap between

57. *This line drawing helps to decode the stories of the king of the monkeys in a painting which is set around a window in the cave. 1) The River Ganges, full of fish, runs from top to bottom 2) The human king and queen bathe in the river 3) The king appears again on horseback 4) The king's archers shoot at the monkeys 5) The monkey king uses his own body to bridge the ravine and allow the other animals to escape 6) The monkey king is shot down and captured in a sheet 7) The monkey king addresses the humans on the responsibilities of monarchy.*

faith and knowledge. Behind the gorgeous clarity of Herringham's copies, that is exactly what we see inside the Ajanta caves: complexity converted into paint.

But in other cases, imagery made a very different kind of intervention into the complexity of religious belief. At roughly the same time as the last of the caves at Ajanta were being decorated, on the other side of the world, art was being deployed much more forcefully in religious controversy.

WHO OR WHAT WAS JESUS?

In the sixth century CE the marshlands of Italy's Adriatic coast became one of the front lines in an ideological war. The early Christians, who were certainly not at this stage a unified faith, argued furiously about fundamental parts of their doctrine. And in these debates they harnessed the fiercest power of art.

The Church of San Vitale at Ravenna – a town which was then a major administrative centre, and now combines heritage tourism with an industrial port – was built in the 540s, paid for by a rich local banker or money lender, and dedicated to a local saint and martyr (St Vitalis, as he was known in Latin). It was partly constructed out of the remains of earlier Roman buildings, the fabric itself becoming a reminder of the Christian 'conquest' of pagan Rome. Throughout the church every technique has been used to assert the Christian message and demonstrate its power; the most stunning of all are the images in shimmering golden mosaic, the great innovation of early Christian artists. One clear part of the message is that the power of God and

58. The spectacular interior of San Vitale, looking into the apse. The dome soars, and expensive marble lines the pillars. Most of the painted decoration on the upper levels is much later; the only original mosaics are in the apse.

the power of the organised Church were pulling together, combined with the power of the Christian Byzantine emperor – who was the direct successor of the Roman emperor, with a capital based in Constantinople, what is now Istanbul (on the site of the earlier Byzantium). In the apse of the building, beneath a scene of Jesus presenting a crown to St Vitalis, are mosaics of the reigning imperial couple decked out in all their finery: Justinian, a military expansionist and ambitious civil reformer (his law code still lies at the foundation of many modern legal systems), sports

the special purple shoes that only emperors were allowed to wear; his wife Theodora, who – so prurient stories claimed – had started life in the entertainment industry, oozes opulence and colour, dripping with elaborate jewellery.

These mosaics, almost certainly planned by a local bishop and close associate of the emperor, were partly an exercise in the kind of monarchical aggrandisement we have already explored. Justinian's forces had conquered Ravenna, taking it from the Ostrogoths in a bid to rebuild the Roman empire on its earlier grand scale. But neither he nor Theodora ever went there – even though, in a sense, they have been in residence ever since, barging their way into the most holy

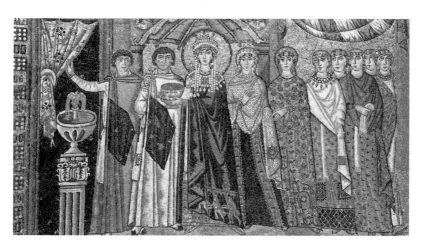

59. Theodora with her retinue. The dress of the empress features the three magi at its hem (a hint perhaps at the gifts royalty might bring), and that of the lady-in-waiting to her right matches the pattern of the robe of St Vitalis (Fig. 60). We should imagine they have just come in from the outside; the fountain on the left belonged in the church courtyard.

ECLESIVSEPIS·

part of this church (where the empress, as a woman, would never have been allowed if she really had turned up in the flesh) and almost hanging on Jesus' coat-tails. True, the artists were very careful not to make Justinian look like the equal of Jesus, but it is hard not to spot the visual rhymes between the human rulers and the divine. The emperor is wearing the same colour as Jesus, and he adopts the same pose as St Vitalis, who himself wears a patterned dress very similar to one member of the retinue of Theodora. And the fact that Justinian is shown with twelve followers is surely an echo of Jesus and his twelve apostles.

Yet, imperial display or not, it is Jesus himself who is unarguably the single most dominating image in the church – and it was he who lay at the heart of the theological battles of the times. The early centuries of Christianity were not a period of peace and goodwill. They were torn apart by religious controversies of many kinds, one at this period more intense than any other: on the nature and divine essence of Jesus. There were crucial issues of belief at stake. What was the exact relationship between Jesus and God? What and where had Jesus been before he was born

60. *The mosaic in the apse. St Vitalis stands on the far left, and Bishop Ecclesius, who first started the building (before it was taken over by Justinian's close associate) is on the far right; the young Jesus is in the centre. The four rivers of paradise beneath Jesus' feet provide a location for the scene.*

61. Jesus as the lamb of God, in the central medallion of the apse ceiling –
supported by two angels.

to Mary? How could a perfect and indivisible god give up part of himself to create a son? And so – and this was the killer question for many – were Jesus and God made of the same substance, or were they just very like each other? These questions were not merely the debating points of the Christian intelligentsia, it was said that in some parts of the world you could not even go to the market for a loaf of bread without being treated to a lecture on the theological position of Jesus by the stall-holder.

The mosaics at San Vitale together add up to a very strong case for the divine status of Jesus, as if to erode

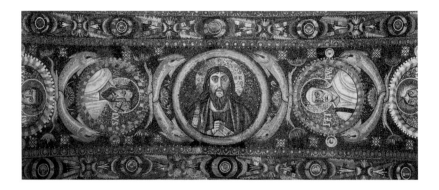

62. *As you pass through the arch into the apse and look up, you see a figure that more or less conflates Jesus and God the father, with the apostles on either side of him; here Peter is on the right, and Paul (counted as an apostle) on the left.*

any misunderstanding. He appears as part of a calculated scheme of images, almost designed to end the controversy, guiding the viewer to the 'right' conclusion. At the east end of the church, in perfect alignment, are images which present three different aspects of Jesus. In the apse there is the young beardless Jesus, the son of God. At the centre of the ceiling is Jesus as the symbolic lamb of God. At the top of the entrance arch is the older, bearded, all-powerful Jesus, as indistinguishable as you could get from God the father. There is a lesson here in *how to see* Jesus, and in that last image in particular a clear steer. This is art offering a resolution of debate. These images are telling us never to doubt the divinity of Jesus Christ.

QUESTIONS OF VANITY

The controversies of religion, however, are not restricted merely to precise points of theology. Elsewhere in the Christian world, at other times, images engage in debates on very different themes, with some unexpected consequences.

Behind the façades of its *palazzi* and churches, the city of Venice contains a treasure trove of religious paintings that remain exactly where they were intended to be seen. Some of the most spectacular were designed in the sixteenth century for the Scuola di San Rocco, the meeting-house (literally 'school') of a religious brotherhood, named after a saint (Rocco, or Roch), who was believed to offer protection against the plague. These Venetian brotherhoods were a combination of charitable and social organisations, not unlike – to oversimplify a little – Renaissance versions of a Rotary Club. Their wealthy members would come together, no doubt with a whole mixture of motives, to share their concerns, selfless or otherwise, for the poor. And in the Scuola di San Rocco the paintings that surrounded them offered reminders of their charitable obligations. There

63. *Canaletto's view of the Scuola di San Rocco in 1735, depicting the visit of the Doge (under the parasol on the left of the building's façade) on the feast day of the saint; it has hardly changed in almost 300 years.*

is no doubt, for example, that Jesus' birth is happening in poverty (mother and baby are making do with a hayloft that is 'ordinary' even by the standards of haylofts). And in the scene of the Last Supper, the most prominent figures in the canvas in front of Jesus and his disciples are two beggars and a hungry dog, presumably hoping for scraps fallen from the table.

Most of this art was the work of Jacopo Tintoretto (a nickname taken from his father's occupation: a dyer, or

64. *In Tintoretto's version of the Nativity, Mary, Joseph and the child are on the upper floor of a rather dilapidated hayloft, while the shepherds arrive below (lower right) to pay homage. But there is rich symbolism too, from the light shining on the baby's face to the peacock above the ox, a symbol of immortality.*

tintore). A younger contemporary of Titian, he was a home-grown Venetian favourite, who spent some twenty years between the 1560s and 1580s under commission to the brotherhood, decorating their meeting-house with over fifty paintings. His most famous image in the building was painted for the room where the organisation's governing council met: a vast scene, almost forty feet across, of the crucifixion of Jesus.

Visitors who come to see this painting now have very different responses to it. Some are overwhelmed by the size, some puzzled by the busy bits of detail. Critics and art historians have had different reactions too. Some have homed in on the painter's technique, picking out Tintoretto's bold brush strokes, or the contrast between light and shade. Some have concentrated instead on the emotion of the scene. That was the line taken by the critic and guru John Ruskin in the nineteenth century, when he claimed that the images left him speechless. 'I must leave this picture to work its will on the spectator,' he wrote, 'for it is beyond all analysis, and above all praise.' It is true that styles of criticism change with the generations, with their different priorities, and no doubt with their different ways of seeing art. But I can't help thinking that maybe Ruskin should have tried a bit harder.

One important thing that Tintoretto did in his version of the crucifixion was to blur the lines between the viewer and

the painting. Some of its characters are wearing modern – that is sixteenth-century – dress, not biblical-style outfits; and there are some apparently ordinary sixteenth-century types doing the digging, tugging on the ropes and putting up the ladders. More than that, if you stand in front of the

65. In this Last Supper, the viewer approaches the table, where Jesus and the huddled apostles are eating, through – and almost from the perspective of – the two beggars who have rested their plate and pitcher on the steps in anticipation of the scraps. There is a striking contrast with the well-ordered kitchen behind.

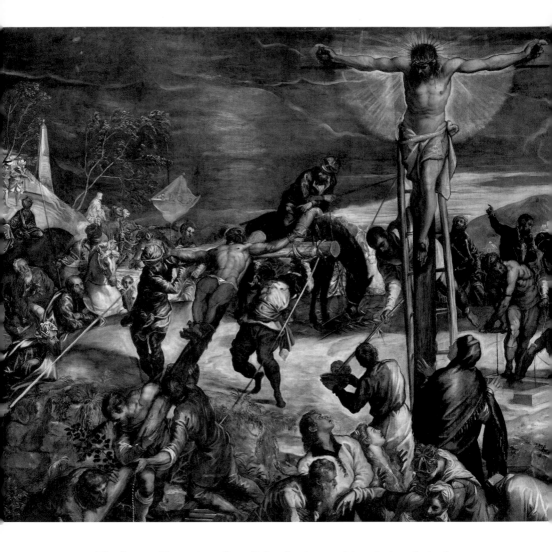

66. *The figure of Jesus, in radiant light, dominates this painting. As in the biblical narrative, two thieves are being crucified with him. The cross of the so-called 'good thief' on the left is just being erected; on the right, the 'bad thief' still lies on the ground. In the background the power of Rome is paraded on a banner reading 'SPQR' now only just visible on the left (short for 'The Senate and People of Rome').*

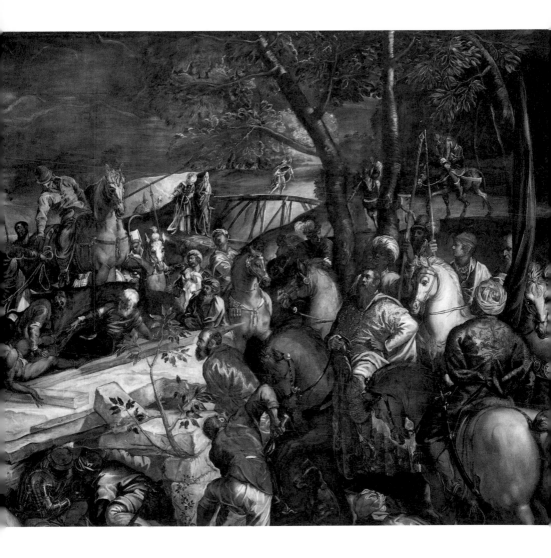

67. *This detail from the foreground of Tintoretto's Crucifixion shows what seem to be ordinary sixteenth-century workmen, playing their part in the biblical scene.*

painting, it is almost as if you become part of the encircling crowd around that central scene. The question of where to draw the line between art object and the day-to-day living world is a common preoccupation of both artist and viewer (it underlies, for example, the story of the sexual assault on the statue of Aphrodite in her temple at Knidos). Here Tintoretto erodes that boundary to hammer home a very particular point: the idea that the crucifixion is both an historical event in past time and a religious event, which breaks down the barriers of time and space, and incorporates its viewers into its own frame.

But there is another, more controversial reading of this painting that sometimes gets lost on the connoisseurs who stand before it in admiration. Tintoretto was paid to paint this at a critical moment in the story of the brotherhood, when they were being attacked for spending far too much on 'bling' and on doing up their premises and by no means enough on helping the poor. The painter seems partly to be responding to that charge. When he included beggars in the scene of the Last Supper, or the kind of people that the brotherhood was supposed to support in the scene of the crucifixion, it goes further than a general reminder of their charitable aims – to become a calculated defence of those aims in the face of criticism. But that whole controversy suggests a crucial problem in religious art: the more you plough your resources into the visual glorification of God,

the more you lay yourself open to the accusation that you are more interested in the material than in the spiritual, that you are more interested in wordly vanities than in piety.

That in turn begins to open up some of the major fault lines between art and religion and the most fundamental problems in picturing the divine. The perils of vanity are only the beginning. They point to the fundamental problem of *idolatry*, or of the worship of images and 'idols', which is faced the world over – and in a spectacular form in Catholic Spain.

A LIVING STATUE?

The city of Seville has been a centre of image-making for centuries. It has been home to some of Spain's greatest religious painters – Velázquez, Zurbarán and Murillo, for example – and images still play an active part in the city's religious life. One of these has a peculiar power. Housed in the church of the Macarena (whose name derives from one of the districts of Seville), it is a statue of the Virgin Mary. She has been here for over 300 years, crying in sorrow at the death of her son Jesus.

She is an extraordinary work of art. She was started in the seventeenth century, according to one story, by a female artist because only a woman, it was imagined, could capture the Virgin quite as splendidly as this. But she has been added to ever since, and is in many ways a work in progress. The lavish gold crown came later, as did the vast capes and the brooches (said to be the gift of a local celebrity matador). In fact, she has a large and varied wardrobe, which is often changed.

The everyday care and attention paid to this statue might

at first sight seem a little odd. But there is a long history going back at least to ancient Greece of divine images being dressed up and regularly re-clothed. And, in any case, this Virgin was intended to have an aura of humanity about her. Underneath she may be no more than a lightweight

68. *The face of the Virgin with its tears of glass and hair just visible under one of her elaborate lace outfits; and pinned to it the brooches said to have been presented by the admiring matador.*

mechanical frame and her tears may be made of glass. Her hair, though, is real human hair, her hands are movable, so that they can take different positions, and her exposed flesh is made of wood, on the grounds that wood is warmer and more organic than marble. One story is that the signs of bruising on her cheek were caused by an angry Protestant, who once threw a bottle at her. In many ways she is treated as if she were a human being, according to the rules of human etiquette; so, for example, no one apart from nuns are allowed to remove her clothes.

At the most sacred time of the Christian year, at Easter, on the evening of 'Good Friday', the statue is taken to the threshold of the church. Carried on a throne it moves into the night; and as it moves, the Virgin seems to come to life, swaying and shimmering in the light. It is as if the *likeness* of the Virgin becomes her *presence*. The reaction of many in the crowds that line the streets is astonishingly emotional: partly tearful, partly ecstatic, partly celebratory.

The Church hierarchy (generally viewed as a conservative group) have usually been kept at arm's length from this and other similar ceremonies in Seville and elsewhere in Spain; and they have much more ambivalent views. Popular piety may be applauded, they concede. But, as with the extravagant decoration at the Scuola di San Rocco, they have always had problems about the cost of it all. Clerics have often objected, and still do, to the fact that people were

pouring money into these celebrations rather than giving it to the poor. There have been concerns too about what some Church authorities perceive as the vulgarity of the image. In the seventeenth century, priests observing this Virgin with all her adornment rather snootily dismissed her as a prostitute rather than a saint. The most pressing problem of all, however, is whether the *image* of the Virgin had stolen the limelight from the Virgin herself.

What are the worshippers worshipping, and how far does their behaviour conflict with the prohibition of idols enshrined in the second of the Ten Commandments ('Thou shalt not make unto thee any graven image ... Thou shalt not bow down thyself to them, nor serve them' in the English 'King James I' version of the Bible)? Is the focus really on the *idea* of the Virgin Mary that exists somehow beyond the image? Or is it on the statue itself? How far is the image being confused with the prototype? For the modern priest, kindly, paternalistic or patronising as he may be, the priority is to remind his flock that the statue is not the be all and end all; but that *through* the statue you might approach the divine. Ultimately it is only a statue, and a representation of something higher.

69. *For most of the year the statue of Mary stands resplendent, though slightly distant, above the altar of the church, almost encased in a gilded frame.*

This is the basic and perennial problem of religious art, which all religions must face. But if almost all religions assume that idolatry is a bad thing, they differ on how idolatry is to be defined, how it is to be handled, and even more fundamentally on the question of what a religious image *is*. That goes back as far as we can see in the art of faith and is still debated now.

70. Once a year, in Christian Holy Week, she is moved onto a float and emerges from the church, to a vast crowd – of the faithful, the tourists, the pious and (no doubt) the cynical.

THE ARTFULNESS OF ISLAM

On the rural fringes of Istanbul is one of the most innovative and startling religious creations of modern times. The work of a visionary Turkish architect, Emre Arolat, it appeared on the landscape less than a decade ago, completed in 2014, and has drawn people in ever since. It's the Sancaklar Mosque named after its sponsor.

Arolat's aim was to harness the power of modernism, often thought of as a very secular artistic and architectural movement, to express the essence of religious space, stripped of all its non-essentials – and merging with its surroundings, as if it was always 'naturally' meant to be there. The mosque is strikingly untraditional in many respects. There is no dome or colour, and it goes some way to break down the gender hierarchies of worship. Women and men still pray separately, but the women are not behind the men, they are parallel. Yet in other ways it exploits the traditions of Islam very heavily, almost writing the history of the religion into the design. The inside space is designed to remind those who enter of the Cave of Hira

where the Prophet Muhammad first received the revelation of the word of God that became the Quran (the cave's combination of natural form and man-made architecture being as important here as at Ajanta, or as in the specially constructed underground shrines (or 'caves') of the god Mithras in the Roman empire). And it also evokes one of the stereotypes that many people now have of Islam: that it is a decidedly *artless* religion, prohibiting not only the images of God but also the images of living creatures which only the creator God could create. The only man-made image in the Sancaklar Mosque is a quote from the Quran ('Remember

71. *The only element of the Sancaklar mosque clearly visible above ground is its single stark minaret. The rest merges with the landscape, almost as if it had always been there.*

your Lord much') inscribed in exquisite calligraphy. It is as if we are expected to come here to see – and to go away with – the word of God.

But Islam is unequivocally not an artless religion. Throughout its history we find no single uncontested position on images of living creatures or on the image of God. In some private contexts, in some branches of the

72. Pilgrims at the Cave of Hira in modern Saudi Arabia, close to Mecca on the mountain Jabal al-Nour, where the prophet meditated and then received the word of God from an angel.

faith, there were even occasionally images of the Prophet himself, and it is said that early Muslim travellers were sometimes overcome with emotion when foreigners showed them pictures of him (though crucially this always happened outside Muslim territory). More generally, in the Middle Ages, the Islamic world was home to some of the most intricate debates on aesthetics, the nature of beauty, the optics of the human eye and our sensory experience of the natural world. This extended to a whole kaleidoscope of stories and parables that were Islam's conversation with itself about the role of the artist and the purposes of

images. One of the most revealing of these takes us into the domestic life of Muhammad.

The story goes that he came home one day to discover that his wife Aisha had acquired a tapestry with images of living creatures woven into the design; and she had hung it up. The Prophet was furious and would not even cross the threshold: it was the creator God who created living creatures, not some tapestry artist. So Aisha took it down, but she did not let the fabric go to waste. She cut it up and turned it into cushion covers. That apparently created no problem.

This is a wonderful illustration of how the boundaries between what is acceptable and what is not can shift

73. *The interior of the mosque clearly evokes the idea of the cave, its only decoration one striking piece of calligraphy: 'Remember your Lord much'.*

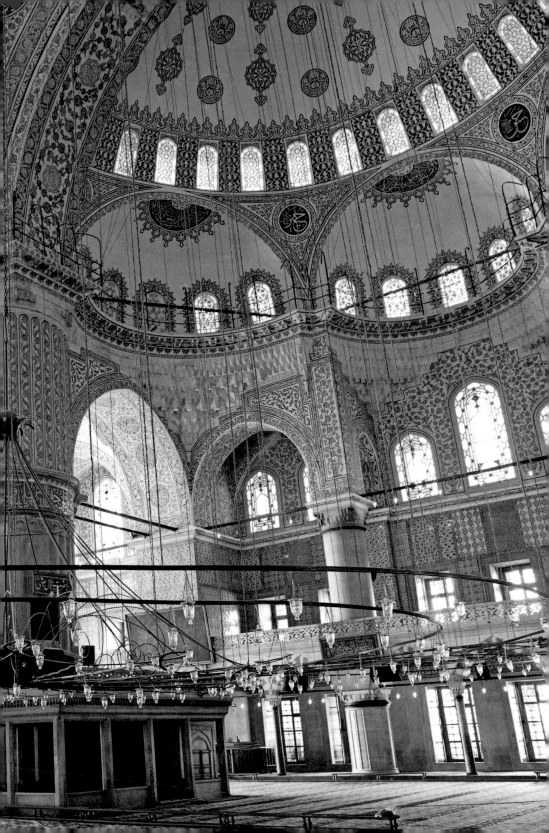

according to the role and the setting of the image. But it is the borderline between art and the written word that is the most significant in understanding the role and definition of images in Islamic culture. For calligraphy – the art of 'beautiful writing' – was at the heart of Islamic identity from the moment that Muhammad received the word of God in the seventh century, and it was the means by which that word was set down, spread and displayed. Exquisite penmanship sets Islam apart from many other religions and it also raises the question of what exactly constitutes an 'art form' – from that single elegant phrase in the Sancaklar Mosque to the most extravagant writing of all, in the Blue Mosque in the centre of Istanbul.

The Blue Mosque was commissioned in the early seventeenth century by the Ottoman Sultan Ahmed and was designed to outdo all other mosques in the city, in size and splendour (a display maybe intended to make up for the young ruler's mixed military record). A few modern architectural critics feel that it tries a little too hard, but one of Ahmed's contemporaries used a significantly military metaphor in dubbing it 'the commander of the whole army of mosques'. Today's worshippers, pilgrims and tourists

74. *Inside the Blue Mosque, now an extraordinary combination of lights, coloured windows and domes. The hefty columns have rarely found much favour with modern architectural historians.*

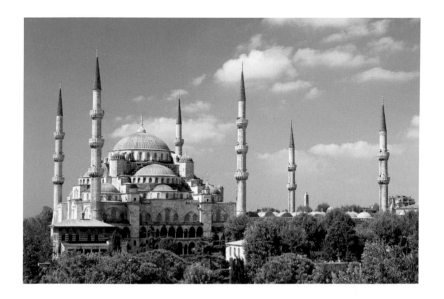

75. The Blue Mosque on the sky-line of modern Istanbul. The boastful claims of this mosque are symbolised in its (rare) six minarets.

seem to agree: they still come here in their millions each year, enjoying the amazing balancing act of the domes and the sparkling light and colour. There are no images of any living creatures; instead the walls are alive with ornate patterns, plants and flowers intertwining in the vivid glaze of ceramic tiles. And laced into the decorative scheme are some of the most extraordinary examples of monumental calligraphy to be found anywhere in the Islamic world. It can almost feel as if the mosque was conceived as a great library of Islamic script: writing at its most powerful in every sense.

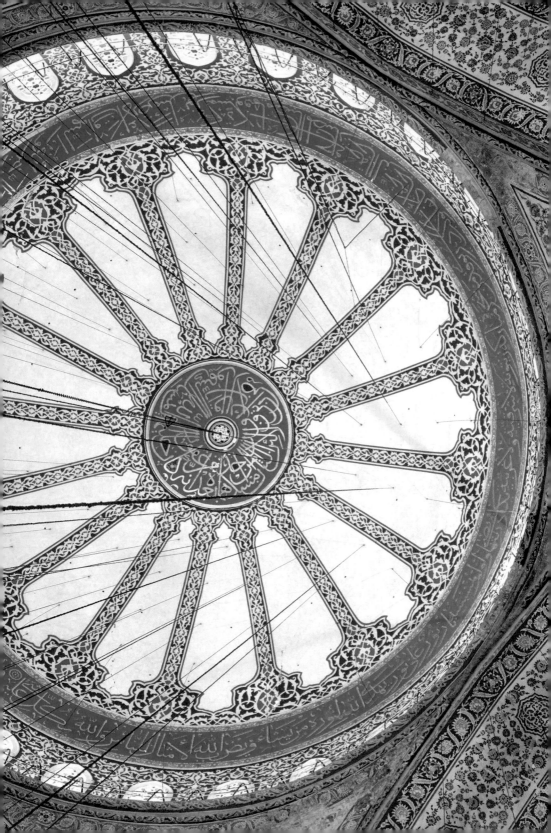

When you walk into the building, there is a quotation above the door which hints that you are about to see something very special, that you are going through the gates of paradise. And that is just one of a series of notices throughout the mosque, often beautifully written lines from the Quran, which guide the thoughts of the faithful and interpret what you see. If you look up into the main dome, you are reminded that it is Allah who supports the heaven and the earth. And as you finally leave the complex, through the door of the courtyard, and go back into the day-to-day world, there is another message, which essentially says you should take with you the state of purity that you have gained inside, through prayer. It is as if there is a written programme here telling you how to experience the building and how to look at it.

Yet for those who worshipped – and still worship – here, this writing has other parts to play. There is certainly more to it than some kind of users' manual. Most of the visitors to the mosque for most of its history would not have been able to read what was written anyway: relatively few of the modern tourists who now come to gasp at the spectacular building can read Arabic; and in its earlier days the majority

76. Looking up high into one of the domes of the Blue Mosque. The elegant writing is barely decipherable from the ground, but it shows how decorative and artful 'the word' can be.

of the faithful who entered to pray here would have been illiterate. Even for those who can – or could – read, most of the words are so high up that they are hard to make out with the naked eye, and the beautifully intricate patterns and rhythms of the calligraphy do not help the legibility. But you do not need to be able to read it to get the big point.

Writing is not always intended to be read; it can work in other ways too, more symbolic than practical. Islamic calligraphy is nothing less than an attempt to represent the divine in visual form, but not as human. It puts God on display *as his word*; it is God seen in the *art* of writing. Some Islamic scholars have compared this to tattoos on the skin of a mosque (they can convey particular messages if you choose to make them, but they are powerful visual symbols in their own right). Or, as one modern calligrapher summed it up, making a more directly religious point, the words are 'a form of blessing and just by looking at it you can absorb some of the blessing'. To put this more strongly, in the context of all the debates within Islam about image making, and in the face of what are often taken to be simple and stringent prohibitions, calligraphy evolved to redefine what an image of God could be, transforming the word into the image.

BIBLE STORIES

In many ways Islam made the art of the word distinctively its own. But it is by no means the only religion to use writing as a way to negotiate the problem of how to represent the divine. The Christian gospels, for example, claim that 'God is the word', and Jewish artists too could sometimes make the most of the overlap between text and image, blurring the boundaries between them even further. There is no more telling, or appealing, example of this than a very special Jewish Bible, transcribed and illustrated in mid-fifteenth-century Spain, and now one of the treasures of the Bodleian Library in Oxford, known (after the eighteenth-century librarian who arranged its acquisition) as the Kennicott Bible.

The Kennicott Bible contains a mass of winning illustration. There have been centuries of debate, within both Judaism and Christianity, about what Moses' Second Commandment meant in practice. What exactly did it outlaw? Was it the *making* or the *worship* of images? And anyway, as we saw in Seville, where was the boundary

77. *This pair of human figures in the Kennicott Bible seems to be a strange accompaniment to the Second Commandment on the same page.*

between using or enjoying images and worshipping them? But, unless there was an appalling contradiction built into their work or they were happy to flout religious law, the designers of this Bible certainly did not take Moses' law to forbid a whole series of extravagant images decorating

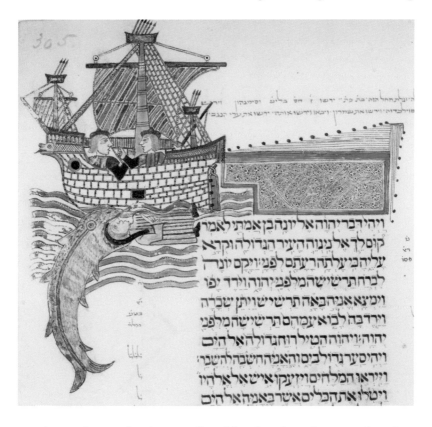

78. *The prophet Jonah is here swallowed by what the Hebrew text describes as a 'giant fish', despite the usual English version 'whale'. According to the biblical story, the fish actually saves Jonah (he had been thrown overboard in a storm for having disobeyed the word of God) and he is soon spewed out in order to continue to do God's work.*

171

the biblical text. Even on the same opening that contains the Second Commandment, you find a pair of little chaps with what appear to be large bare bottoms; and throughout, dancing around and alongside the writing, are images of Jewish symbols and Bible stories (from a splendid full-page menorah to the scene of a strikingly passive Jonah entering the whale's mouth).

What makes this Bible particularly precious, though, is that it comes out of a brief moment in Spanish history in the fifteenth century when Jewish, Muslim and Christian

79. *The 'tiny writing' here (in the white spaces of the pattern) is so tiny that it is almost impossible to make out, still less to read.*

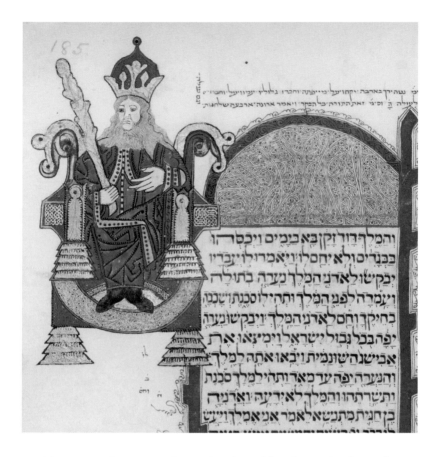

*80. This image of King David seated on his golden throne closely matches
the image of the King in contemporary decks of Spanish playing cards.*

artistic traditions came together in a really productive
way. Religions are often not as isolationist as we imagine;
they rub shoulders and influence one another, not only in
doctrine but in representation too. Here the artist seems
almost to celebrate the mixed culture and artistic blending

of late medieval Spain. There is a lovely image on one page, which looks for all the world like an Islamic carpet, and must derive from some kind of Islamic model; but it is surrounded by a text in absolutely minuscule script ('micrography' – or 'tiny writing' – as it is technically called), which is a specifically Jewish tradition. On another page, the biblical King David is shown, but in a form and style that is clearly based on a European playing card.

The artist who produced these pages of images proudly signed his name over a whole page at the very end of the book. 'I Joseph Ibn Hayyim, decorated and finished this.' Jewish Bibles are not very often signed by their artists. When they are, they are certainly not signed in a way that takes a whole page, or with outsized Hebrew letters like these, formed out of human figures – some naked, some clothed – and animals. The individual characters of the name are here formed out of the bodies of men and woman contorted into the appropriate shapes, or curious hybrids of the human form and bird or beast (there is a stripy fish with a man's head balanced on his tail and another cheeky bottom, this time being pecked by a bird with a ferocious beak). It is all wonderful chutzpah. Joseph is the kind of

81. *The letters of the name of the artist at the end of the Kennicott Bible are constructed out of all kinds of living things, human and animal, naked and clothed, fanciful and (almost) realistic.*

artist who, even at the very end of his work, cannot keep himself or his artistry in.

But there is much more than a name in this. In his own humorous way, Joseph is pointing to important questions about the nature of images, addressing the fundamental issues of word and image that divide many religions. And, with a grin, as he writes himself into the Bible he has so gloriously decorated, he suggests that the debate can be resolved: in his hands the written word and the human body become one and the same thing.

It would have been very nice to leave the story there. But its end is far more poignant. In 1492, less than twenty years after Joseph proudly finished his work, the Catholics expelled the Jews from Spain in a murderous purge. This Bible survives as a witness not only to integration but also to the horrible realities of religious war. And it is to war and conflict – both within and between religions – that we now turn, with contests around images often at their centre.

THE SCARS OF BATTLE

'Iconoclasm' – from the Greek meaning 'image-breaking' – has been a major element in Christian religion for centuries, the destruction of religious art going almost hand-in-hand with the appreciation or adoration of it. As the anxiety around the statue of the Virgin Mary in the church of the Macarena made very clear, it was always easy enough to deplore idolatry, harder to agree what counts as such. Yet – leaving aside the Protestant with his bottle, if that story is true – there seems to have been no campaign of physical attacks on the Macarena Virgin. In other places and at other times, throughout the history of Christianity, there have been violent and sustained clashes between 'image-lovers' and 'image-breakers'. These differ in their specific causes, historical contexts, narratives and cast of characters, but they share some significant common themes.

One of the fiercest periods of this intermittent conflict takes us back to the eighth century, under 200 years after the theological controversies of early Christianity that were built into the church of San Vitale. It started in 726 in the

capital of the Byzantine empire (modern Istanbul), when – so it was said – the emperor ordered that the image of Jesus be removed from the façade of his imperial palace. Why the longstanding debates about the role of images erupted with such intensity at this point has always been a mystery. (Was it part of the Byzantine emperor's attempts to impose his authority on the Church? Was it the influence of Islam?) But, whatever the reasons, the removal of that one painting has come to represent the beginning of an official ban on all kinds of images of the divine – painting, sculpture, mosaic – that lasted on and off for more than a hundred years.

Ultimately the 'image-lovers' emerged victorious, and many of the arguments from their side of the story still survive. They had clear justifications for the use of religious images: they made churches more beautiful; they were a powerful help in teaching the faithful about the tenets of the Church; and they made the holy seem 'real'. And lurid stories were spread about the evil of the iconoclasts, which went so far as to suggest that the wickedness of those who destroyed images of Jesus was second only to those who crucified Jesus in the first place. As usual in history, we have very little from the losers' – that is the iconoclasts' – side,

82. *The church of St Eirene (Holy Peace) in modern Istanbul, rebuilt in the 740s, gives a glimpse of the aesthetic of the iconoclasts. The bare brick walls would have been covered with sheets of marble; the only decoration in the apse an elegant, almost modernist, cross.*

although we can make a good guess at what their arguments would have been (the Second Commandment would have been a start). Apart from one surviving church in Istanbul, austerely elegant to my eyes, we know almost nothing about the style of religious environment they favoured. And there is very little trace left of the destruction they brought about.

But thousands of miles away, almost a thousand years later, and in a very different context, we can get a clearer glimpse of the work of another group of Christian iconoclasts, and of its complexity. It was one element in the series of conflicts between Protestant Christians and Catholic Christians, fought out in England in the sixteenth and seventeenth centuries. These conflicts involved all kinds of issues of theological doctrine and contested politics, and a major flashpoint and an important symbol of difference between the warring sides were religious images. The scars can still be seen in churches and cathedrals across the country, where the 'idolatrous icons' and other 'excesses' associated with Catholicism were destroyed or removed by the ascendant Protestants. There are particularly eloquent scars in a landmark of the Fens (the marshlands) of eastern England: Ely Cathedral, which though later much restored, remains a jewel of Gothic architecture of the Middle Ages. It is unforgettable for the cavernous nave, the ornate carving that still reflects the medieval colours, and the extraordinary octagonal lantern high above, almost opening

up into the heavens. But during the great religious schism, the splendour of Ely fell victim to one of England's most determined Protestant reformers.

On 9 January 1644, Oliver Cromwell, who was then governor of Ely, marched into Ely Cathedral in what is one of the most mythologised and probably highly embellished incidents in these English religious civil wars. It is hard to imagine in the tranquillity of modern Ely, but the story goes that Cromwell went up to the priest who was conducting evening service, told him to put away his (Catholic) version of the prayer book and to stop the choir singing (a 'turn off the music' moment). On the following days, it is said, he actively encouraged – or at least did nothing to stop – his troops turning on the fabric of the building, on the images and on the glass. As they made their way through the vestry and the cloisters, they smashed the place.

Cromwell's attack was only one assault in a long campaign against the images at Ely. Viewing them as the product of Catholic superstition and a distraction from the pure word of God, the reformers had no doubt that the images must go. And it was in the Lady Chapel (the chapel in the cathedral dedicated to the Virgin Mary) that there remains the clearest evidence of widespread destruction

83. Ely Cathedral, looking up into the great 'lantern' and down the nave (whose coloured ceiling is part of the nineteenth-century restoration).

84. The destruction at Ely often left the figures more or less intact, while removing the heads or other particularly loaded parts of the body. Cases of total destruction were very limited.

wreaked on another occasion decades before Cromwell. Iconoclasm of many different kinds, and with different targets, happened here. The original stained glass windows were one casualty, but the iconoclasts also attacked the sculpted figures of saints, kings and prophets, and scenes from the life of the Virgin. Sometimes the whole sculpture was removed, but often it is only the head and hands, leaving the body in place. It is as if they were aiming to destroy those parts of the sculpture that seemed most of all

85. Iconoclasm changed the aesthetic of the Lady Chapel at Ely – but not necessarily for the worse, as the light and airy space we now see testifies.

to give it the power of the living, or those parts with which people engaged most intensely. This was not just a series of random acts of vandalism but destruction that was targeted, even thoughtful, and set against a background of debates about the power and potential dangers of religious images.

Iconoclasm is something we often, understandably, deplore, whether it is the defacement of precious images of the pagan gods by early Christians, the demolition of the great Buddhas of Bamiyan by the Taliban, or – most recently – the destruction of some of the Roman remains at Palmyra by ISIS. We regret the loss of what has been destroyed and the violence against innocent human victims that is often part of the process; indeed, our reactions now often reflect those of the image-lovers, who tend to present the work of the iconoclasts as at best mindless thuggery, at worst evil savagery. Sometimes it is. But it can often be more complicated. What happened at Ely suggests another way of seeing this. Here most of those figures – minus heads, minus hands – have not been made invisible. It is almost as if they have been turned into a different kind of image in their own right. The statues now standing proud, bearing the scars of their mutilation, have become a visual narrative of religious conflict.

But there are further, no doubt unintended, consequences to this artful destruction. Once again it depends on how we choose to look. Whatever our vested

interest in those fundamental theological debates about idolatry and religious images, there is not only devastation on view here. Liberated, you might almost say, from the figures of saints, kings and prophets that once crowded the walls, and with its clear stainless windows, the Lady Chapel has been transformed into another version of beauty. In its current state it is a tremendously aesthetically pleasing space: not only light and airy, but a marvellous mixture of austerity and decoration, a fine balance between destruction and creation. We owe *that* to the iconoclasts.

HINDU IMAGES, ISLAMIC IDIOMS

It is those paradoxes that we often overlook when we tell the artistic story of iconoclasm. But they emerge intriguingly in another example from a very different religious conflict: one between the expanding world of Islam in the twelfth century and the Hindu traditions of the Indian subcontinent.

In the late 1100s Muslim armies from Afghanistan invaded northern India. By all accounts, they were horrified by what they found. This was the home of the Hindu religion, where people worshipped not one god but, on some counts, millions. Worse still, artists across India were kept busy creating a never-ending array of the idols that played such an important part in Hindu faith. Muslim writers as far back as the tenth century BCE often presented India as a place of image worship gone mad, and even as the very origin of (in their terms) idols themselves. One story

86. The minaret in the complex of the Quwwat-ul-Islam Mosque, begun in the 1190s and developed into the thirteenth century.

had it that these religious images only spread more widely in the world because they had been washed away from India by the waters of Noah's flood. So how did Islam deal with the religious images with which they came face-to-face?

There were plenty of tales, sent back home to the Muslim world, about how the invaders smashed the idols and destroyed the Hindu temples. In truth, the history of the encounter, and Islamic reactions, on this and other occasions, were much more nuanced than that. As well as

87. Some of the Hindu elements incorporated into the later Islamic structures. As at Ely, although key aspects of the human form have been defaced, the essential humanity remains.

repugnance, there was also fascination with Hindu images and with India's place in the history of idols. Some images circulated in the Islamic world, as curios and collectables. And another revealing story tells of some golden statues, captured during the Islamic conquest of Sicily. They weren't destroyed. They were packed off back to India by the Muslims, as if in an act of repatriation. One of the best examples of this nuance is found in the first mosque to be erected in Delhi, the Quwwat–ul-Islam Mosque.

Constructed in the 1190s, this was once known as the most imposing mosque in the world. Huge arches form a grand gateway, a towering minaret proclaims Islam as the one true faith and around the central courtyard is an elaborate colonnade. It is easy to imagine this as a sanctuary for the Muslims who made it, an island of Islam in an idolatrous Hindu world. But in this building the Hindu world is not so distant as it might seem.

Various elements of earlier Hindu structures and images have been reused and incorporated into the fabric of the mosque, the human figures often defaced. One point of this must be to assert the conquest by Islam and to show how the Hindu 'idols' have been, at least, neutralised (not unlike the triumphalist use of pagan fabric in the Christian church of San Vitale). But, on closer inspection, it is also striking that, even when they have been defaced, some aspects of the humanity of these human figures have been preserved.

The simple fact that the builders of the new mosque have chosen fairly consistently to place the reused figures the right way up suggests a respect for the human form and its image. There is, in other words, continuity as well as rupture. It is a strong hint that some of the craftsmen employed on this mosque here were trained in Hindu traditions and were probably Hindu themselves. But it also betrays a certain appreciation of the very images that Islam condemned. Just like at Ely Cathedral, it demonstrates that even in the most radical cases of iconoclasm, art lives on – inextricably bound to faith.

FAITH IN CIVILISATION

I want to end by going back to the ancient world, and to what was then one of the western world's most renowned religious places, one of the richest, most colourful and intense sacred spaces anywhere, and a phantasmagoria of religious images: the Acropolis in Athens. It is not easy to appreciate that now. The dusty, barren, slippery surface we walk on today is nothing to do with any religious iconoclasm, but is actually the creation of nineteenth-century archaeologists who – in their zeal to get to the bottom, literally, of the site – stripped everything away down to the raw bedrock, and left standing just one or two monuments of the glory days of classical Athens in the fifth century BCE. But 2,500 years ago this place was a feast for the eye and the imagination. It was full of gods, full of the stories of gods, and of their associations, their possessions, their statues. It used to be said that the divine figures themselves had once walked in this place. You could still see the rock where some god had sat down to take a rest, or the place where the god Poseidon had jammed his trident into

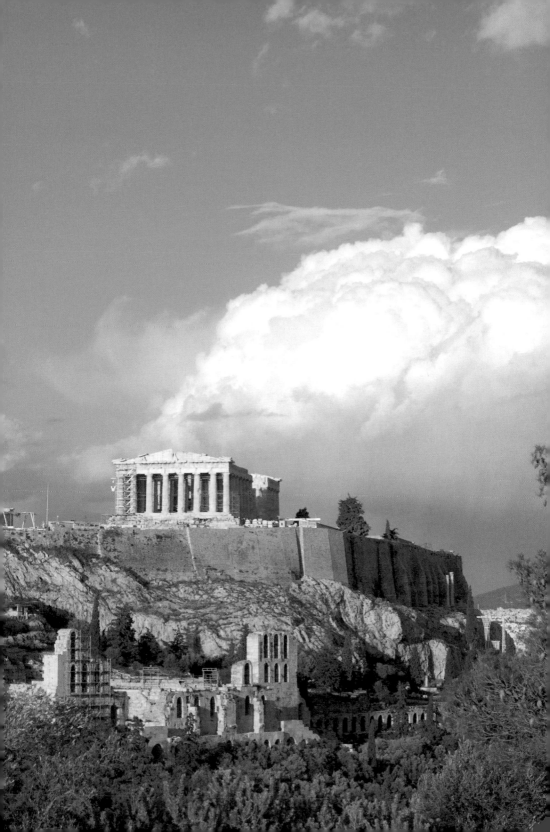

the ground. Everywhere you looked there were religious offerings, altars for sacrifice, and temples.

It must also have been full of debates among its ancient visitors about how gods should be represented, and what the most authentic image of a divinity was. These pagan gods can now seem to our eyes a very alien crowd, with all the elaborate myths of their personal quarrels, and their petulant or malevolent interventions in the lives of human beings. But classical literature still preserves the flavour of a lively tradition of religious controversy over how they should be represented that strikes a chord with many of the more familiar later disputes.

One notable philosopher of the sixth century BCE, Xenophanes, originally from the west coast of what is now Turkey, challenged the whole idea of representing gods in human form when he argued that if horses and cattle could paint and sculpt they would make images of the gods in the form of horses and cattle. Others suggested that the best form of divine statue was not man-made but natural, possibly even the gift from the gods themselves. One intriguing story tells of a group of fishermen from the island

88. *The Acropolis in Athens, dominated by the fifth-century* BCE *Parthenon, with the monumental gateway to the left. It is a sanitised version of the site: most of the later structures have been stripped away by nineteenth-and early twentieth-century archaeologists, to leave a rather barren shrine to classical culture.*

89. The Parthenon was the inspiration behind the UNESCO logo, grounding one international version of culture and cultural heritage in the classical Greek past.

of Lesbos who found a piece of driftwood caught in their nets, with markings that looked rather like a face. Assuming that it must be the face of a god, they consulted the oracle at Delphi, who confirmed that it was the god Dionysus (it ended up as an object of worship on the island, with a bronze copy being sent to Delphi). Likewise, on the Acropolis itself, there was an ancient image of the goddess Athena, housed in the temple we now know as the Erechtheion, that was according to ancient writers (the object itself is long lost) basically an olive wood plank – which some believed had miraculously dropped to earth from heaven.

But the most famous statue there – also destroyed centuries ago, perhaps in a massive fire – was of a very different kind: a colossal figure of Athena, made from gold and ivory, extravagantly adorned, and in human form. It was the centrepiece of the most splendid temple on the Acropolis, the Parthenon (the temple of Athena, the Virgin, or 'Parthenos'), built in the middle of the fifth century BCE, out of the profits of Athens' empire. Large as it was, this was not the largest temple in the Greek world (that accolade

probably goes to the Temple of Artemis at Ephesus), but it has become renowned for the precision of its architectural design and for its extraordinary decoration. There was exquisite sculpture on almost every place on the building you could possibly fit it. Not all the Athenians at the time were as impressed with this as we are. Some claimed that it was all too extravagant, part of a project to dress up Athens like a whore. Others joked about the families of mice that made their homes up the skirts of statues like the Athena Parthenos (whose gold and ivory construction was not solid, but built around a frame much like that under the clothing of the Virgin Mary in Seville).

Only the bare bones of the ancient temple have survived, or indeed of the later religious structures that, after the end of antiquity, used its skeleton for their own purposes. The story of that longer history has usually been overshadowed by the image of the glittering temple of Athena. But for hundreds of years it continued to stand, first adapted into a Christian church, then under the Ottoman empire into an Islamic mosque. One English traveller in 1675 called it 'the finest mosque in the world' (another claimant to that title), and it seems from other contemporary descriptions that, despite Islamic prohibitions, some of the classical sculptures that had originally decorated it were still visible. There is a certain irony in the fact that the survival of the pagan Parthenon is owed to its conversion by Christians

90. After the destruction of the Parthenon in 1687, another mosque was constructed in its ruins – seen here in a watercolour of 1836 by the Danish artist Christian Hansen.

and by Muslims, each religion finding a convenient home (as well, no doubt, as a symbol of its own dominance) in taking over the sacred space of its predecessors. And perhaps there is a further irony in the fact that it is only because of a devastating explosion in 1687 – during the conflicts between Venice and the Ottoman empire, when the Parthenon mosque, then doubling as a munitions store,

was hit by Venetian cannon fire – that the building was finally ruined.

But the site raises other religious questions for us. How do we look at an ancient monument designed to house a divinity who is for almost all of us, apart from a handful of pagan revivalists, a museum piece or an antique curiosity? It is easy to look at a place like the Acropolis and to assume that whatever religion was once here is gone for good: paganism is dead, and the traces of Christianity and Islam have been all but obliterated (no archaeologist wanted to preserve the remains of the mosque). Certainly, the crowds of tourists, enduring the shadeless sun as they are lectured by their guides, do not appear to have their minds on God, or the gods. At best they seem to be following in the footsteps of Christiana Herringham and converting what they see into cultural heritage. But we should be a little more thoughtful.

However secular we might feel when we gaze at the ruins of the Parthenon, when we admire its art and engage with its mythology, many of us are reflecting on questions that religions have often helped us face. Where do I come from? Where do I belong? What's my place in human history? There is a modern *faith* here, even if we do not recognise

91. *The Parthenon has provided the backdrop for probably millions of photographs and 'selfies' over the last century, from film stars to fascist generals – and academics. It is a testament to our faith in civilisation.*

it as such. It is one we call 'civilisation'. It is an idea that behaves very much like a religion, offering grand narratives about our origins and our destiny, bringing people together in shared belief. And the Parthenon has become its icon.

So if you ask me what *is* civilisation, I say it's little more than an act of faith.

AFTERWORD: CIVILISATION AND CIVILISATIONS

It was my own encounters with ancient Greece that first raised in my mind the big questions – about *How Do We Look?* and *The Eye of Faith* – that lie behind this book. I still recall how unsettling it was to learn, as a student, that the beautifully painted Greek ceramics that I had always assumed belonged in the spotlight as 'great art' had originally been made in an industrial operation as fairly ordinary household crockery. I wonder even now how far it is possible entirely to escape the pure, gleaming white vision of antiquity that J. J. Winckelmann bequeathed us, and to see the sometimes gaudy vulgarity beyond. And I wonder too how we can recapture the surprise that must have been felt by those who first looked on those early revolutionary Greek sculptures or those first western nudes that we now take for granted as part of the cultural landscape.

So much depends on *who* is looking, from ancient master or ancient slave to eighteenth-century connoisseur or twenty-first-century tourist. And so much depends *on the context* in which they look, whether ancient cemetery

or temple, English stately home or modern museum. I am not sure that it is ever possible entirely to recreate the views of those who first saw classical art, and I am not sure that it is the be all and end all of our understanding anyway (the changing ways these objects have been seen through the centuries is an important part of their history too). But I have tried in *Civilisations* to reflect the domestic ordinariness – and occasionally the flamboyance – of some ancient art, and I have tried to recapture something of 'the shock of the new'.

In working on both the book and the television series, I have had the opportunity to think harder about these questions in different places and at different periods, coming face-to-face with a very wide range of works of art, from Olmec heads to the terracotta warriors. Inevitably I have found myself in dialogue with Kenneth Clark's original version of *Civilisation*. For anyone who chooses to compare the two, the differences will be obvious – and not all of those can be put down to the cultural changes of the last fifty years.

It is not simply a matter of his patrician and apparently self-confident air ('I think I can recognise it when I see it,' as he claimed). More important, I have taken care to avoid Clark's stress on the 'great male artist'. Despite the feminism of the 1960s, the vision of art that he offered in 1969 barely included women in any active capacity at all, apart from a

few society hostesses, prison reformer Elizabeth Fry and the Virgin Mary. I have not only shifted the focus from creator (one damn genius after the next) to consumer, I have also given women their due share of the limelight in the story of 'civilisation': from Christiana Herringham, who struggled with the bees and the bats and her own preconceptions to preserve the paintings at Ajanta, to Boutades' daughter who, according to legend, took out her lamp and pencil to draw the silhouette of her lover. I have included too a wider range of places and cultures. Clark's view of civilisation was heavily focused on Europe (and not even all of that: Spain, for example, was entirely omitted); and he did not always trouble to disguise his sense of the superiority of 'our' civilisation over the barbarity elsewhere. Although many parts of the world necessarily remain unrepresented in this book (*Civilisations* is no gazetteer), it is emphatically *not* one whose horizons are restricted to Europe.

That said, I have come to realise the difficulties in escaping some of Clark's constraints. Until the globalisation of the twentieth century (and very partially even then), there can be no single narrative of art and culture across the world. It was only by concentrating on Europe that Clark was able to tell a single coherent story. My story has no such running thread, but only sporadic intersections (such as the visit of the Roman emperor Hadrian to the sights of ancient Egypt). It is inevitable that the links I have

drawn between my case studies – often far distant in time and place – are largely thematic rather than chronological. Besides, the problems of a European or western focus are not simply 'solved' by including non-western art. Here too a lot depends on who is looking and in what context. Paradoxically to cast a white western gaze over the art of the world – even to shoehorn it into a 'history of art' whose framework was ultimately devised by Winckelmann – risks becoming almost as ethnocentric a project as restricting that gaze to Europe. I am nevertheless convinced that we gain more than we lose in making the attempt to look more widely. In working on this project my own eyes have been opened to different ways of seeing.

For all the disagreements and frustrations with him that I have now, I have also come to appreciate more clearly what I owe to Kenneth Clark. I can remember watching his television series when I was fourteen. That too opened my eyes. The idea that 'civilisation' in Clark's sense, even restricted to Europe, had a *history* that could be told and analysed was something that had never struck me in quite that way. And *Civilisation*, even as I saw it in black and white, introduced me to places that I had never seen before, and hardly dreamt of. I had then been abroad just once, on a family holiday to Belgium. When the cameras followed Clark as he stood before us next to Notre Dame in Paris, King Charlemagne's throne in Aachen, Giotto's frescoes in

92. In very different times, cigarette in hand, Kenneth Clark stands against the background of Notre Dame in Paris.

Padua or the Botticellis in the Uffizi in Florence, I took the trip with him and discovered a much wider world of art, culture and countries to explore; and, with him as guide, I picked up the idea that there was something to be said about it all, a history to be told, and sense to be made.

By a nice coincidence, just a few weeks after the last episode of Clark's thirteen-part series *Civilisation* had been

broadcast in May 1969, the lunar module from the Apollo 11 spacecraft touched down on the moon. I remember sitting up to the early hours of the morning to watch – thanks to the television cameras – Neil Armstrong become the first human being to put his feet on the lunar surface. For me, the thrill of being taken to a world beyond my own was very similar to the excitement I had felt in front of *Civilisation*. I could not now say for sure which had the greatest impact long term (though I suspect it might have been Clark!). But both were examples of television at its most mind-expanding best.

FURTHER READING AND REFERENCES

Introduction: Civilisations and Barbarities
The original BBC television series of *Civilisation* is still available on DVD, and a version was published as Kenneth Clark, *Civilisation: A Personal View* (London, 1969). There was a notable response to Clark a few years later by John Berger, in a television series and a book, *Ways of Seeing* (London, 1972), whose priorities are much closer to my own (and I occasionally echo the nice formulation of his title). Gombrich's words on artists are from the introduction to *The Story of Art* (rev. ed., London, 1995, first published 1950). Academic art history has turned its attention to viewers, consumers, responses and social context for decades; useful introductions to different aspects of this can be found in Dana Arnold, *Art History: A Very Short Introduction* (Oxford, 2004), A. L. Rees and F. Borzello (eds.), *The New Art History* (London, 1986) and Janet Wolff, *The Social Production of Art* (London and Basingstoke, 1981). But the figure of the artist as creative genius still remains the focus of popular exhibitions, television presentations and most non-specialised work in the subject.

1. HOW DO WE LOOK?

Prologue: Heads and Bodies
Some of the best general guides to Olmec culture (and heads) can be found in exhibition catalogues: for example, Elizabeth P. Benson and Beatriz de la Fuente (eds.), *Olmec Art of Ancient Mexico* (National Gallery of Art, Washington DC, 1996), and Kathleen Berrin and Virginia M. Fields, *Olmec: Colossal Masterworks of Ancient Mexico* (Fine Arts Museums of San Francisco and Los Angeles County Museum of Art, 2010). See also, for a fuller account, Christopher A. Pool, *Olmec Archaeology and Early Mesoamerica* (Cambridge, 2007). The original context of this and other colossal heads at the Olmec site of La Venta is

carefully discussed by Rebecca B. González Lauck, 'The Architectural Setting of Olmec Sculpture Clusters at La Venta, Tabasco', in Julia Guernsey, John E. Clark and Barbara Arroyo (eds), *The Place of Stone Monuments: Context, Use, and Meaning in Mesoamerica's Pre-Classic Transition* (Dumbarton Oaks, Washington DC, 2010), pp. 129–48.

A Singing Statue

Elizabeth Speller, *Following Hadrian: A Second-Century Journey through the Roman Empire* (London, 2002) offers a lively introduction to the emperor's visit to Memnon; for 'Memnon tourism', in general, see G. W. Bowersock, 'The Miracle of Memnon', *Bulletin of the American Society of Papyrologists* 21 (1984), pp. 21–32. Cynical doubts about the source of the sound are expressed by Strabo, *Geography* 17, 1, 46, writing at the end of the first century BCE; the 'lyre with a broken string' is the comparison of Pausanias, *Guide to Greece* 1, 42, 3, in the second century CE. The full texts of the inscriptions on the statue's leg (including a much shorter one by Sabina herself) are collected in A. and E. Bernand, *Les inscriptions grecques et latines du colosse de Memnon* (Paris, 1960). The poetry of Julia Balbilla is discussed in detail, with English translations of the sometimes obscure Greek, by T. Corey Brennan, 'The Poets Julia Balbilla and Damo at the Colossus of Memnon', *Classical World* 91 (1998), pp. 215–34 and Patricia Rosenmeyer, 'Greek Verse Inscriptions in Roman Egypt: Julia Balbilla's Sapphic Voice', *Classical Antiquity* 27 (2008), pp. 334–58 (slightly re-ordering the chronology of the imperial visit). 'Some is atrocious' is the judgement of E. L. Bowie, in D. A. Russell (ed.), *Antonine Literature* (Oxford, 1990), p. 62.

Greek Bodies

One of the best introductions to the cultural history of Athens is Paul Cartledge, *The Greeks: A Portrait of Self and Others* (rev. ed., Oxford & New York, 2002); and for a general history of art in the classical period, see Robin Osborne, *Archaic and Classical Greek Art* (Oxford, 1998). The phrase 'city of images' goes back to Claude Bérard and others, *A*

City of Images: Iconography and Society in Ancient Greece (Princeton, 1989), which explores the cultural world of Athenian pot painting. The portrayal of women on Athenian ceramics is a major theme in Mary Beard, 'Adopting an Approach II', in Tom Rasmussen and Nigel Spivey (eds.), *Looking at Greek Vases* (Cambridge, 1991), pp. 12–35, and at greater length in Sian Lewis, *The Athenian Woman: An Iconographic Handbook* (London & New York, 2002); for a wider treatment of the position of women in classical antiquity, see Elaine Fantham and others (eds.), *Women in the Classical World: Image and Text* (New York & Oxford, 1994). François Lissarrague, *The Aesthetics of the Greek Banquet: Images of Wine and Ritual* (Princeton, 1990, reissued 2014) is a classic discussion of the ideology of the Athenian drinking party; his essay 'The Sexual Life of Satyrs', in David M. Halperin, John J. Winkler and Froma I. Zeitlin (eds.), *Before Sexuality: The Construction of Erotic Experience in the Ancient Greek World* (Princeton, 1990), pp. 53–81, puts the excesses of the satyrs in context.

The Look of Loss

Phrasikleia's statue is contextualised in Osborne, *Archaic and Classical Greek Art* (above), chapter 5. The colouring and decoration of the statue are discussed in detail by Vinzenz Brinkmann and others, 'The Funerary Monument to Phrasikleia', in Brinkmann, Oliver Primavesi and Max Hollein (eds.), *Circumlitio: The Polychromy of Antique and Medieval Sculpture* (Munich, 2010), pp. 187–217, available online at http://www.stiftung-archaeologie.de/koch-brinkmann,%20 brinkmann,%20piening%20aus%20CIRCUMLITIO_Hirmer_ Freigabe.pdf. Jesper Svenbro, in *Phrasikleia: An Anthropology of Reading in Ancient Greece* (Ithaca & London, 1993), uses the inscription on the statue to introduce a wider study of the uses of reading in ancient Greece. Susan Walker and Morris Bierbrier, *Ancient Faces: Mummy Portraits from Roman Egypt* (London, 1997) and Euphrosyne Doxiadis, *The Mysterious Fayum Portraits: Faces from Ancient Egypt* (London, 2000) both offer good introductions to mummy portraits

(including Artemidoros). Peter Stewart does the same for Roman portraits more generally in *Roman Art* (Greece and Rome New Surveys in the Classics, Oxford, 2004), chapters 1 and 3, and *The Social History of Roman Art* (Cambridge, 2008), chapter 3. For a detailed study of portraiture and Roman funerary traditions, see Harriet I. Flower, *Ancestor Masks and Aristocratic Power in Roman Culture* (Oxford and New York, paperback ed., 1999). The story of Boutades' daughter is told by Pliny, *Natural History* 35, 151. It is discussed, with other shadow tales, in E. H. Gombrich, *Shadows: The Depiction of Cast Shadows in Western Art* (rev. ed., New Haven & London, 2014) and Victor Stoichita, *A Short History of the Shadow* (London, 1997), chapter 1.

The Emperor of China and the Power of Images

A collections of essays edited by Jane Portal, *The First Emperor: China's Terracotta Army* (London, 2007), originally compiled to accompany an exhibition of some of the terracotta figures in the British Museum, is a good overall guide to the army and its historical context (including brief reference to the destruction, p. 143). There is detailed discussion of the function of the figures in Jessica Rawson, 'The Power of Images: The Model Universe of the First Emperor and Its Legacy', *Historical Research* 75 (2002), pp. 123–54, Jeremy Tanner, 'Figuring Out Death: Sculpture and Agency at the Mausoleum of Halicarnassus and the Tomb of the First Emperor of China', in Liana Chua and Mark Elliott (eds.), *Distributed Objects: Meaning and Mattering after Alfred Gell* (New York & Oxford, 2013), pp. 58–87, and in Ladislav Kesner, 'Likeness of No One: (Re)Presenting the First Emperor's Army', *Art Bulletin* 77 (1995), pp. 115–32 (who coined the phrase I quote). The importance of the discovery of the army, and of its museum display, in the cultural politics of modern China is discussed by David J. Davies, 'Qin Shihuang's Terracotta Warriors and Commemorating the Cultural State', in Marc Andre Matten (ed.), *Places of Memory in Modern China: History, Politics, and Identity* (Leiden, 2012), pp. 17–49.

Supersizing a Pharaoh

Joyce Tyldesley's *Ramesses: Egypt's Greatest Pharaoh* (London, 2000) is a popular biography of the pharaoh (whose name has several variant modern spellings); T. G. H. James, *Ramses II* (New York & Vercelli, 2002) is a lavishly illustrated account, focusing on the art and architecture associated with him. Warwick Pearson, 'Rameses II and the Battle of Kadesh: A Miraculous Victory?', *Ancient History: Resources for Teachers* 40 (2010), pp. 1–20, discusses the representation of Rameses' military 'victories', with further detailed consideration of the reliefs in the Ramesseum by Anthony J. Spalinger, 'Epigraphs in the Battle of Kadesh Reliefs', *Eretz-Israel: Archaeological, Historical and Geographical Studies* (2003), pp. 222–39. Campbell Price offers a sophisticated analysis of the colossal images of Rameses in 'Ramesses, "King of Kings": On the Context and Interpretation of Royal Colossi' in M. Collier and S. Snape (eds.), *Ramesside Studies in Honour of K. A. Kitchen* (Bolton, 2011), pp. 403–11, and of colossi more generally in 'Monuments in Context: Experiences of the Colossal in Ancient Egypt', in Ken Griffin (ed.), *Current Research in Egyptology 2007* (Oxford, 2008), pp. 113–21. The Egyptian references and historical sources behind Shelley's poem are reviewed by J. Gwyn Griffiths, 'Shelley's "Ozymandias" and Diodorus Siculus', *Modern Language Review* 43 (1948), pp. 80–84, with further suggestions in Eugene M. Waith, 'Shelley's "Ozymandias" and Denon', *Yale University Library Gazette* 70 (1996), pp. 153–60.

The Greek Revolution

The impact of Egypt on early Greek sculpture is assessed by Jeffrey M. Hurwit, *The Art and Culture of Early Greece, 1100–480 BC* (Ithaca & London, 1985), chapter 4, and Osborne, *Archaic and Classical Greek Art* (above), chapter 5; particular arguments against substantial Egyptian influence are offered, for example, by R. M. Cook, 'Origins of Greek

Sculpture', *Journal of Hellenic Studies* 87 (1967), pp. 24–32. Notable attempts to confront the 'Greek Revolution' include: E. H. Gombrich, *Art and Illusion: A Study in the Psychology of Pictorial Representation* (rev. ed, Princeton, 1961) chapter 4 (but see the highly theoretical critique of Gombrich's position, not specifically focused on ancient material, in Norman Bryson, *Vision and Painting: The Logic of the Gaze* (London, 1983), chapter 2), Richard Neer, *The Emergence of the Classical Style in Greek Sculpture* (Chicago, 2010), and Michael Squire, *The Art of the Body: Antiquity and Its Legacy* (London & New York, 2011), chapter 2. The connection with democracy was explicitly drawn in Diana Buitron-Oliver (ed.), *The Greek Miracle: Classical Sculpture from the Dawn of Democracy, the Fifth Century* BC (National Gallery of Art, Washington DC, 1992), full text available free online (https://www.nga.gov/content/dam/ngaweb/research/publications/pdfs/the-greek-miracle.pdf). Jaś Elsner, 'Reflections on the "Greek Revolution" in Art: From Changes in Viewing to the Transformation of Subjectivity', in Simon Goldhill and Robin Osborne (eds.), *Rethinking Revolutions through Ancient Greece* (Cambridge, 2000), pp. 68–95, explicitly raises the question of what was lost in the revolution. Stanley Casson in 'An Unfinished Colossal Statue at Naxos', *Annual of the British School at Athens* 37 (1936/37), pp. 21–5, discusses the statue at Apollonas in detail. The beard has suggested that the god Dionysus is the intended subject of the colossus (though, confusingly, the name of the local village may actually be connected to a belief that the statue represented Apollo). The most up-to-date and accessible discussions of the Boxer are https://www.metmuseum.org/blogs/now-at-the-met/features/2013/the-boxer and Jens Daehner, 'Statue of a Seated Boxer' in Daenher and Kenneth Lapatin (eds.), *Power and Pathos: Bronze Sculpture of the Hellenistic World* (Florence & Los Angeles, 2015), pp. 222–3. Some puzzles about its discovery are addressed by Elon D. Heymans, 'The Bronze Boxer from the Quirinal Revisited: A Construction-Related Deposition of Sculpture', *BABESCH* 88 (2013), pp. 229–44. The eyewitness account of the discovery of the Boxer is

from Rodolfo Lanciani, *Ancient Rome in the Light of Recent Discoveries* (Rome, 1888), pp. 305–6.

The Stain on the Thigh

The anecdote of Zeuxis and Parrhasios is told by Pliny, *Natural History* 35, 65–6, and has been often discussed in detail since: note Stephen Bann, *The True Vine: On Visual Representation and Western Tradition* (Cambridge, 1989), chapter 1, Helen Morales, 'The Torturer's Apprentice: Parrhasius and the Limits of Art', in Jaś Elsner (ed.), *Art and Text in Roman Culture* (Cambridge, 1996), pp. 182–209, and (on Pliny's views), Sorcha Carey, *Pliny's Catalogue of Culture: Art and Empire in the Natural History* (Cambridge, 2003), chapter 5. The significance of the first female nude is the theme of Squire, *The Art of the Body* (above), chapter 3. The various versions and copies of the Aphrodite of Knidos are assembled and analysed in Christine Mitchell Havelock, *The Aphrodite of Knidos and Her Successors: A Historical Review of the Female Nude in Greek Art* (Ann Arbor, 1995). The fullest version of the story of the assault on Aphrodite's statue is found in Pseudo-Lucian, *Love Stories* (or *Erotes* or *Amores*) pp. 11–17, a literary essay that has come down to us wrongly attached to the works of the second-century CE writer Lucian, and probably written a century or so later (hence 'Pseudo-Lucian'). Among many useful discussions, see Simon Goldhill, *Foucault's Virginity: Ancient Erotic Fiction and the History of Sexuality* (Cambridge, 1995), chapter 2, Mary Beard and John Henderson, *Classical Art, from Greece to Rome* (Oxford, 2001), chapter 3 (in the context of a more general discussion of the nude) and Jonas Grethlein, *Aesthetic Experiences and Classical Antiquity: The Significance of Form in Narratives and Pictures* (Cambridge, 2017), chapter 6. David Freedberg includes the statue in a more wide-ranging discussion of 'arousal by image', in *The Power of Images: Studies in the History and Theory of Response* (rev. ed., Chicago, 1991).

The Revolution's Legacy
The website of Syon Park (https://www.syonpark.co.uk/) includes a brief illustrated history of the house's architecture and decoration. The designs for the interior are discussed in greater detail by David C. Huntington, 'Robert Adam's "Mise-en-Scène" of the Human Figure', *Journal of the Society of Architectural Historians* 27 (1968), pp. 249–63, and by Eileen Harris, *The Genius of Robert Adam: His Interiors* (New Haven & London, 2001), chapter 4. The whole collection of the first Duke and Duchess will be the subject of Adriano Aymonino, *Patronage, Collecting and Society in Georgian Britain: The Grand Design of the 1st Duke and Duchess of Northumberland* (New Haven & London, forthcoming). The Renaissance and later history of the Apollo Belvedere and Dying Gaul (or Gladiator) is laid out in Francis Haskell and Nicholas Penny, *Taste and the Antique: The Lure of Classical Sculpture 1500–1900* (New Haven & London, 1981), pp. 148–51 and 224–7. The most convenient translation of Winckelmann's *History* is by Harry Francis Mallgrave, *Johann Joachim Winckelmann, History of the Art of Antiquity* (Los Angeles, 2006), with a useful introduction by Alex Potts (the description of the Apollo: pp. 333–4). I have quoted Kenneth Clark's words from the first episode of the televised version of *Civilisation*; it is worth noting that – very uncomfortably for us – in the 'book of the series' he contrasts the Apollo explicitly with an African mask, and the 'Hellenistic' with the '*Negro*' imagination (Kenneth Clark, *Civilisation* (above), p. 2). Beard and Henderson, *Classical Art* (above), chapter 2, offers a concise introduction to Winckelmann. A fuller study can be found in Alex Potts, *Flesh and the Idea: Winckelmann and the Origins of Art History* (New Haven & London, 1994).

The Olmec Wrestler
Esther Pasztory, 'Truth in Forgery', *RES: Anthropology and Aesthetics* 42 (2002), pp. 159–65, presents the technical and historical against the authenticity of the Wrestler, as well as some useful reflections on 'fakes'.

2. THE EYE OF FAITH

Prologue: Sunrise at Angkor Wat

Russell Ciochon and Jamie James, 'The Glory That Was Angkor', *Archaeology* 47 (1994), pp. 38–49, is a useful introductory account of Angkor Wat; the wider historical context is surveyed by Charles Higham, *The Civilization of Angkor* (Berkeley & Los Angeles, 2001). Thomas J. Maxwell and Jaroslav Poncar, *Of Gods, Kings and Men: The Reliefs of Angkor Wat* (Chiang Mai, 2007), is a photographic record of the relief sculpture. A special issue of *Antiquity* vol. 89, issue 348 (2015) – was devoted to recent archaeological work on the temple and its context. Peter D. Sharrock, 'Garuda, Vajrapāni and Religious Change in Jayavarman VII's Angkor', *Journal of Southeast Asian Studies* 40 (2009), pp. 111–51, and Jinah Kim, 'Unfinished Business: Buddhist Reuse of Angkor Wat and Its Historical and Political Significance', *Artibus Asiae* 70 (2010), pp. 77–122, discuss different aspects of the change from Hinduism to Buddhism. The impact of tourism at Angkor is the subject of Tim Winter, *Post-Conflict Heritage, Postcolonial Tourism: Culture, Politics and Development at Angkor* (Abingdon & New York, 2007).

Who's Looking? 'Cave Art' at Ajanta

The quotation from Basava is from his poem 'The Pot is a God', which can be found in full in A. K. Ramanujan (trans.), *Speaking of Shiva* (Harmondsworth, 1973), p. 84; gods on trucks (focusing on Pakistan) are discussed by Jamal J. Elias, 'On Wings of Diesel: Spiritual Space and Religious Imagination in Pakistani Truck Decoration', *RES: Anthropology and Aesthetics* 43 (2003), pp. 187–202. William Dalrymple, 'The Greatest Ancient Picture Gallery', *New York Review of Books* (23 October, 2014) tells the story of the first rediscovery of the Ajanta caves, with a brief introduction to their history and earlier attempts to copy the paintings. The life of Christiana Herringham and her work at Ajanta, and elsewhere, is the subject of Mary Lago, *Christiana*

Herringham and the Edwardian Art Scene (London, 1996), including discussion (pp. 225–9) of the possible connection with Forster's Mrs Moore. Herringham published the paintings in *Ajanta Frescoes: Being Reproductions in Colour and Monochrome of Frescoes in Some of the Caves at Ajanta ... with Introductory Essays by Various Members of the India Society* (London, 1915). The precise chronology of the caves and their paintings is disputed; the seven volumes on the site by Walter M. Spink, *Ajanta: History and Development* (Leiden & Boston, 2005–17), present a minutely detailed study of those problems. How to read the scenes is the theme of Vidya Dehejia, 'On Modes of Visual Narration in Early Buddhist Art', *Art Bulletin* 72 (1990), pp. 374–92, and 'Narrative Modes in Ajanta Cave 17: A Preliminary Study', *South Asian Studies* 7 (1991), pp. 45–57 (with detailed discussion of the monkey painting).

Who or What Was Jesus?
Robin Cormack, *Byzantine Art* (rev. ed., Oxford, 2018), chapter 2, gives a concise introduction to San Vitale and its decorative programme. Deborah Mauskopf Deliyannis, *Ravenna in Late Antiquity* (Cambridge, 2010), is a full study of the history, art and architecture of the town between 400 and 751 CE, along with Judith Herrin and Jinty Nelson (eds.), *Ravenna: Its Role in Earlier Medieval Change and Exchange* (chapter 4 includes the history of the decoration of San Vitale). Much has been written on the imperial mosaic panels; note Jaś Elsner, *Art and the Roman Viewer: The Transformation of Roman Art from the Pagan World to Christianity* (Cambridge, 1995), chapter 5, and Sarah E. Bassett, 'Style and Meaning in the Imperial Panels at San Vitale', *Artibus et Historiae* 29 (2008), pp. 49–57. John Moorhead, *Justinian* (London, 1994) and J. A. S. Evans, *The Empress Theodora: Partner of Justinian* (Austin, 2002), introduce the imperial couple. A taste of the controversies in Christianity at this period can be found in the early chapters of Diarmaid MacCulloch, *A History of Christianity: The First Three Thousand Years* (London, 2009), especially chapters 6 and 7. The story of the eagerness of ordinary people to discuss theology is buried

in Gregory of Nyssa's fourth-century treatise *On the Divinity of the Son and the Holy Spirit* (translation from original Greek into French available, by Matthieu Cassin, *Conférence (Paris)* 29 (2009) pp. 581–611, relevant passage p. 591: 'if you ask the price of bread, the answer comes "the Father is the greater, the Son less"').

Questions of Vanity
The website of the Scuola di San Rocco (the brotherhood still exists) provides a good 'official' introduction to its history: http://www.scuolagrandesanrocco.org/home-en/. A classic account of the brotherhoods ('confraternities') is Christopher F. Black, *Italian Confraternities in the Sixteenth Century* (paperback ed., Cambridge, 2003). For Tintoretto's work at the Scuola, and its political and religious background, see David Rosand, *Painting in Sixteenth-Century Venice: Titian, Veronese, Tintoretto* (rev. ed., Cambridge, 1997), chapter 5, and Tom Nichols, *Tintoretto: Tradition and Identity* (rev. ed., London, 2015), chapters 4 and 5. John Ruskin is lost for words in *Stones of Venice* (London, 1853) p. 353; to be fair to Ruskin, he wrote about the painting at greater length in the second volume of *Modern Painters* (London, 1846) as discussed by Stephen C. Finley, *Nature's Covenant: Figures of Lanscape in Ruskin* (Unversity Park, PA, 1992), chapter 6.

A Living Statue?
Almost every modern guidebook to Seville repeats the important (but not necessarily historically accurate) popular stories about the statue of the Macarena, which are now embedded in the oral tradition of locals and tourists alike. Elizabeth Nash, *Seville, Córdoba and Granada: A Cultural History* (Oxford, 2005) chapter 1, offers an introductory account, which is rather more critical. The Macarena Virgin and other processional sculpture in Seville is the subject of the detailed academic study by Susan Verdi Webster, including full reference to the archival and other material on the anxieties of the clergy: *Art and Ritual in Golden-Age Spain: Sevillian Confraternities and the Processional*

Sculpture of Holy Week (Princeton, 1998); she has considered particular aspects of this more briefly (sometimes with only passing reference to the Macarena) in, for example, 'Sacred Altars, Sacred Streets: The Sculpture of Penitential Confraternities in Early Modern Seville', *Journal of Ritual Studies* 6 (1992) pp. 159–77, and 'Shameless Beauty and Worldly Splendor: On the Spanish Practice of Adorning the Virgin', in E. Thunø and G. Wolf (eds.), *The Miraculous Image in the Late Middle Ages and Renaissance* (Rome, 2004), pp. 249–71 (on the controversies about the these statues' 'worldly' and expensive clothing). Twentieth-century veneration, adornment and politicisation of the statue are discussed by Linda B. Hall, *Mary, Mother and Warrior: The Virgin in Spain and the Americas* (Austin, 2004), chapter 9. Colm Tóibín, *The Sign of the Cross: Travels in Catholic Europe* (London, 1994), chapter 3, cleverly evokes the complex engagement of different parts of the crowd during Holy Week. I have borrowed the stress on 'likeness' and 'presence' from Hans Belting, *Likeness and Presence: A History of the Image before the Era of Art* (Chicago & London, 1996), an important book on divine imagery; these themes are also discussed by Freedberg, *The Power of Images* (above).

The Artfulness of Islam

The Sancaklar Mosque is discussed by U. Tanyeli 'Profession of Faith: *Mosque* in *Sancaklar*, Turkey by Emre Arolat Architects', *Architectural Review*, 31 July, 2014 (freely available on-line at https://www.architectural-review.com/today/profession-of-faith-mosque-in-sancaklar-turkey-by-emre-arolat-architects/8666472.article and on the architect's website http://emrearolat.com/eaa-projects_pdf/Sancaklar%20Mosque.pdf. The relationship of the mosque to Islamic traditions is the subject of Berin F. Gür, 'Sancaklar Mosque: Displacing the Familiar', *International Journal of Islamic Architecture* 6 (2017), pp. 165–93. For the 'caves' of Mithras, see Mary Beard, John North and Simon Price, *Religions of Rome*, vol. 2 (Cambridge, 1998), chapter 4. Jamal J. Elias, *Aisha's Cushion: Religious Art, Perception and*

Practice in Islam (Cambridge, Mass., 2012), is an important and wide-ranging discussion of debates on images within Islam. For images of Muhammad, see, for example, Oleg Grabar, 'The Story of Portraits of the Prophet Muhammad,' *Studia Islamica* 96 (2003), pp. 19–38, Robert Hillenbrand, 'Images of Muhammad in al-Biruni's *Chronology of Ancient Nations*', in Hillenbrand (ed.), *Persian Painting from the Mongols to the Qajars: Studies in Honour of Basil W. Robinson* (London, 2000), pp. 129–46, and, for excellent illustrations online, the Persian miniatures in Edinburgh University Library are at images.is.ed.ac.uk (search 'Prophet Muhammad'). The story of Aisha is told in one of the accounts of Muhammad's life (hadith) in the *Sahih* of al-Bukhari 4, 54, p. 447. Godfrey Goodwin, *A History of Ottoman Architecture* (London, 1971), chapter 9, reviews the architecture and decoration of the Blue Mosque (or 'Sultan Ahmed Cami'). Early reactions to the Blue Mosque are discussed in Suraiya Faroqhi, *Subjects of the Sultan: Culture and Daily Life in the Ottoman Empire* (London & New York, 2007), chapter 7; the poem, with the phrase 'army of mosques', can be found in Howard Crane, *Risāle-i mi'māriyye: An Early-Seventeenth-Century Ottoman Treatise On Architecture: Facsimile With Translation and Notes* (Leiden, 1987), pp. 73–6. Two useful discussions of the role of calligraphy in Islam are Erica Cruikshank Dodd, 'The Image of the Word: Notes on the Religious Iconography of Islam', *Berytus* 18 (1969), pp. 35–62, and Anthony Welch, 'Epigraphs as Icons: The Role of the Written Word in Islamic Art', in Joseph Gutmann (ed.), *The Image and the Word: Confrontations in Judaism, Christianity and Islam* (Missoula, 1977), pp. 63–74.

Bible Stories

A complete digital version of the Kennicott Bible (which also includes a treatise on grammar) is available free online at the Digital Bodleian: https://digital.bodleian.ox.ac.uk/ (search 'MS Kennicott 1'), with a useful introduction at http://bav.bodleian.ox.ac.uk/news/the-kennicott-bible. Sheila Edmunds, 'A Note on the Art of Joseph Ibn

Hayyim', *Studies in Bibliography and Booklore* 11 (1975/76) pp. 25–40, discusses the iconography, as does Katrin Kogman-Appel, *Jewish Book Art between Islam and Christianity: The Decoration of Hebrew Bibles in Medieval Spain* (Leiden & Boston, 2004), chapter 7. The wider tradition of 'zoomorphic letters' (letters made in the shape of living creatures) is the theme of Erika Mary Boeckeler, *Playful Letters: A Study in Early Modern Alphabetics* (Iowa City, 2017). Different aspects of the history of Jews and Judaism in Spain are explored in Mark D. Meyerson, *A Jewish Renaissance in Fifteenth-Century Spain* (Princeton, 2004), and Jonathan S. Ray, *After Expulsion: 1492 and the Making of Sephardic Jewry* (New York, 2013).

The Scars of Battle
An enormous amount has been written on Byzantine iconoclasm, and the contemporary arguments on either side. Important recent discussions include Thomas F. X. Noble, *Images, Iconoclasm, and the Carolingians* (Philadelphia, 2009), chapters 1 and 2, Jaś Elsner, 'Iconoclasm as Discourse: From Antiquity to Byzantium', *Art Bulletin* 94 (2012) pp. 368–94, and Cormack, *Byzantine Art* (above), chapter 3 and epilogue (p. 92 reproduces a vivid illustration from the ninth-century 'Khludov Psalter' which equates iconoclasts with those who crucified Jesus). Some of the most detailed arguments in favour of images are found in a sermon of the patriarch Photios (*Homily* XVII) given at the inauguration of a mosaic of the Virgin Mary in the church of St Sophia in 867, translated in Cyril Mango, *The Homilies of Photios, Patriarch of Constantinople* (Cambridge, Mass., 1958). The history and architecture of Ely Cathedral is the subject of Peter Meadows and Nigel Ramsay (eds.), *A History of Ely Cathedral* (Woodbridge, 2003). The destruction under Oliver Cromwell is discussed by Graham Hart, 'Oliver Cromwell, Iconoclasm and Ely Cathedral', *Historical Research* 87 (2014), pp. 370–76. Clark, *Civilisation* (above), chapter 6, and Andrew Graham Dixon, *A History of British Art* (Berkeley & Los Angeles, 1999), chapter 1, both deplore the earlier iconoclasm in the

Lady Chapel; this is also discussed by Gary Waller, *The Virgin Mary in Late Medieval and Early Modern English Literature and Popular Culture* (Cambridge, 2011), chapter 1, and by Sarah Stanbury, *The Visual Object of Desire in Late Medieval England* (Philadelphia, 2008), introduction (whose view on the resulting aesthetic is closer to my own).

Hindu Images, Islamic Idioms

Muslim views and stories about Indian 'idols' are discussed by Yohanan Friedmann, 'Medieval Muslim Views of Indian Religions', *Journal of the American Oriental Society* 95 (1975), pp. 214–21, and Elias, *Aisha's Cushion* (above), chapter 4. Mrinalini Rajagopalan, *Building Histories: The Archival and Affective Lives of Five Monuments in Modern Delhi* (Chicago, 2016), chapter 5, highlights the complex cultural amalgam of the Quwwat–ul-Islam mosque. Other continuities between Hindu and Islamic art and architecture are a major theme of Finbarr B. Flood, *Objects of Translation: Material Culture and Medieval 'Hindu-Muslim' Encounter* (Princeton, 2009); see also his nuanced discussion of Islamic iconoclasm up to the destruction of the Bamiyan Buddhas in 'Between Cult and Culture: Bamiyan, Islamic Iconoclasm, and the Museum', *Art Bulletin* 84 (2002), pp. 641–59.

Faith in Civilisation

Mary Beard, *The Parthenon* (rev. ed., London, 2010), introduces the history and imagery of the Acropolis, with a discussion of the conversions of the temple into church and mosque, and of its final destruction. Robin Osborne, *The History Written on the Classical Greek Body* (Cambridge, 2011), chapter 7, explores ancient Greek debates about the nature of gods and how they should be represented. The words of Xenophanes (which now survive only in quotations by later, often Christian, authors) are collected in G. S. Kirk, J. E. Raven and M. Schofield, *The Presocratic Philosophers: A Critical History with a Selection of Texts* (Cambridge, 1983), chapter 5. The story of the piece of wood from the sea is told by Pausanias, *Guide to Greece* 10, 19, 3, who

refers to the miraculous origin of the old statue of Athena at 1, 26, 6. Evidence for the gold and ivory statue is comprehensively analysed by Kenneth D. S. Lapatin, *Chryselephantine Statuary in the Ancient Mediterranean World* (Oxford, 2001), chapter 5; the mice in statues like that in the Parthenon are joked about in Lucian's second-century CE burlesque, *Zeus Rants* 8 – and in *The Battle of Frogs and Mice* (an ancient skit on the *Iliad*) the character of Athena complains about mice nibbling her clothes (lines 177–96). For different traditions on the destruction of the statue, see Beard, *The Parthenon* (above), chapter 3. The 'finest mosque in the world' are the words of George Wheler, *A Journey into Greece in the Company of Dr Spon of Lyons* (London, 1682), p. 352.

Afterword: Civilisation and Civilisations
The original series of *Civilisation*, its background, making and impact is the subject of Jonathan Conlin, *Civilisation* (London, 2009), and in the catalogue accompanying an exhibition devoted to Clark, Chris Stephens and John-Paul Stonard (eds.), *Kenneth Clark: Looking for Civilisation* (Tate Gallery, London, 2014). The series is fully discussed in James Stourton, *Kenneth Clark: Life, Art and Civilisation* (London, 2016).

MAJOR SITES AND LOCATIONS

Some of the places I have explored in this book are major international heritage sites, visited altogether by millions of people each year: the *Tomb of the First Emperor* in Shaanxi province in central China; the *great temples sponsored by Rameses II* near modern Luxor in Egypt; *Angkor Wat* in Cambodia; *San Vitale*, one of the most famous early medieval churches of Ravenna in Italy; the *Blue Mosque* in Istanbul; the *Acropolis* in Athens. Others are less well-known or off the beaten track:

1. How Do We Look?: The *Olmec head* discussed in the prologue has been moved from its original location (which was threatened by petroleum exploration) and can now be found in the Parque-Museo La Venta, a slightly bizarre zoo-cum-archaeological park in Bulevar Ruiz Cortines, Villahermosa, Tabasco State. The *Colossi of Memnon* are easily accessible at the roadside between the Valley of the Kings and the town of Luxor. The *unfinished statue on the island of Naxos* lies, delightfully unguarded, in its original quarry near the village of Apollonas at the north of the island (accessible by car); the convenient steps shown in the photo on p. 72 have since been removed. Another two statues in a similar state remain near the village of Melanes in the centre of the island (they too are free to visit, but local directions are likely to be needed). *Syon House*, still the property of the Dukes of Northumberland, stands in parkland just to the west of central London, though it is not particularly easy to access by public transport. It is regularly open to visitors three days a week during summer months.

2. The Eye of Faith: The *Ajanta Caves* in Maharashtra State are open six days a week (currently closed Monday) but – roughly sixty miles from the nearest large town of Aurangabad, or forty from the smaller Jalgoan – they remain relatively difficult to reach. There are local buses

but most foreign visitors go there in organised groups or take taxis from Aurangabad. The *Scuola di San Rocco* in central Venice, a few minutes' walk from the Grand Canal, is open daily, apart from Christmas and New Year's Day. The *Church of the Macarena* is a little to the north of the main tourist heart of Seville, but easily accessible on local public transport. The building itself is a reconstruction of the 1930s, open daily free of charge (though closed in the afternoons). The *Sancaklar Mosque* is in Büyükçekmece off the E80 highway leading west from the centre of Istanbul; open daily free of charge, it is hard to reach except by car or taxi. *Ely Cathedral*, ninety miles north of London, is within easy walking distance of Ely mainline train station and is open daily. The *Quwwat–ul-Islam Mosque* is in New Delhi, alongside other Islamic monuments in the 'Qutb Minar Complex'; it is open daily and well connected to local public transport.

Almost all the individual objects I have discussed are on permanent public display in major museums. In the *British Museum* in London are the two fifth-century Athenian pots depicting the raucous satyrs and the perfect wife; and the mummy of Artemidoros. Phrasikleia is in the *National Archaeological Museum* in Athens (along with an array of ancient Greek statues that clearly document the change we call the 'Greek Revolution'); the Boxer now lives in *the National Museum, Palazzo Massimo alle Terme*, a few minutes' walk from Rome's main railway station. There are later copies and versions of the Aphrodite of Knidos in many large museums, from the *Metropolitan Museum*, New York to the *Louvre* in Paris. The original of the Apollo Belvedere is in the *Vatican Museums* and that of the Dying Gaul in the *Capitoline Museums*, Rome. The *National Museum of Anthropology* in Mexico City displays the Olmec Wrestler and other Olmec artefacts. The Kennicott Bible is in the *Bodleian Library*, Oxford. It is fully available online at https://digital.bodleian.ox.ac.uk/ (search 'MS Kennicott 1') and periodically on display in the Bodleian's Weston Library exhibition galleries.

ACKNOWLEDGMENTS

Making a television programme is a collaborative process. Most of the ideas in this book have been thrashed out, argued over, laughed at and refined by my colleagues on the *Civilisations* team at the BBC and Nutopia, in London and on location. The finished product on screen and page owes an enormous amount to Mark Bell, Denys Blakeway, Caroline Buckley, Jonty Claypole, Mel Fall, Matt Hill, Andy Hoare, Duane McClunie, Phoebe Mitchell-Innes, David Olusoga, Johann Perry, Nick Reeks, Ewan Roxburgh and Simon Schama; and it owes a lot also to those who undertook the practical arrangements that made the project possible Becky Claridge, Joanna Marshall and Jenny Wolf. There is no more misleading line in television credits than the one that reads 'written and presented by …' as if you had thought of it all yourself and then brought it to the screen. It is as a small gesture to correcting that impression that I dedicate this book to Matt Hill (who was my director and who will recognise some of his ideas and his nice turns of phrase here) and 'the team'.

In writing the book I have also relied on many old friends. Peter Stothard read and improved every page, as did Bob Weil. I picked the brains of my husband Robin Cormack (my live-in Byzantinist), of my children Zoe and Raphael Cormack (who also prepared the Timeline), and of Jaś Elsner, Jeremy Tanner and Carrie Vout. Françoise Simmons helped me out with Christiana Herringham, and the eagle eyes of Debbie Whittaker saved me from errors of all kinds, and from much more.

Publishing too is a collaborative process. At Profile, Penny Daniel saw the book through from start to finish with the good humour that I have come to rely on. Many thanks go to her, James Alexander (of Jade Design), Claire Beaumont, Pete Dyer, Andrew Franklin, Emily Hayward Whitlock (at the Artists' Partnership), Lesley Hodgson, Simon Shelmerdine and Valentina Zanca. Another great team.

BCE

1500 · · · · 1000 · · · · 500 400 300 200 100 0

Americas

← Olmec Colossal Heads →
(1500–400 BCE)

Olmec Wrestler
(if genuine)
(1200–400 BCE)

Europe

Colossus of Aphrodite of Knidos Dying Gaul
Apollonas (330 BCE) (?50 BCE)
(c. 620 BCE)

Parthenon
(438 BCE)

Phrasikleia Apollo Belvedere
(c. 550 BCE) (?c. 300 BCE)

The Boxer
(300–50 BCE?)

←→
Greek Revolution

Asia

Terracotta Army
(210 BCE)

Ajanta Cave
Paintings (first)
(100s BCE)

Africa

Luxor Temple
(1400 BCE)

Ramesseum
(1200s BCE)

Colossi of Memnon
/Amenhotep III
(1350 BCE)

CE

0 · · · · 500 · · · · 1000 · · · · 1500 1600 1700 1800 1900 2000

Olmec Wrester
(if fake)
(1900s CE)

Kennicott Bible
(1476 CE)

Johann
Winckelmann
(1717–1768 CE)

Sancaklar
Mosque
(2014 CE)

Church of San Vitale
Ravenna (540s CE)

Tintoretto's work in
Scuola di San Rocco
Venice (1560s–1580s CE)

BBC *Civilisation*
(1969 CE)

Expulsion of
Jews of Spain
(1492 CE)

Cromwell in
Ely Cathedral
(1644 CE)

Blue Mosque
(1616CE)

Syon House
(1796 CE)

Angkor Wat
(1100s CE)

Ajanta Cave
Paintings (last)
(400s CE)

Quwwat al-Islam
Mosque, Delhi
(1193 CE)

Christiana
Herringham
at Ajanta
(1906–1911 CE)

Hadrian Visits
Egypt
(130 CE)

Artemidoros
Portrait
(100–150 CE)

LIST OF ILLUSTRATIONS

1. How Do We Look?: 1. Detail of Olmec head © National Geographic Creative / Alamy Stock Photo; 2. Olmec head © Brian Overcast / Alamy Stock Photo; 3. Olmec head © fergregory / iStock / Getty Images Plus; 4. Albani Antinous / Digital image courtesy of the Getty's Open Content Program; 5. The Colossi of Memnon © Bildagentur-online / UIG via Getty Images; 6. Mary Beard at the Singing Statue © BBC/Nutopia; 7. Inscription on Memnon's foot © jackie ellis / Alamy Stock Photo; 8. Attic Hydria © The Trustees of the British Museum; 9. Attic Psykter © The Trustees of the British Museum; 10. Detail of Attic Psykter © The Trustees of the British Museum; 11. Detail of slave on Red figured Attic krater © Granger, NYC / TopFoto; 12. Kore by Aristion at the tomb of Phrasikleia © National Archaeological Museum, Athens, Greece / Tarker / Bridgeman Images; 13. Mummy portrait of a priest of Serapis, from Hawara, Egypt © The Trustees of the British Museum; 14. Egyptian mummy portrait, Hawara, Egypt © The Trustees of the British Museum; 15. Mummy-portrait, Roman Period, Saqqara © The Trustees of the British Museum; 16. Mummy case and portrait of Artemidorus © The Trustees of the British Museum; 17. Detail of Mummy case and portrait of Artemidorus © The Trustees of the British Museum; 18. Togatus Barberini, Centrale Montemartini Museum, Rome © Leemage / Corbis via Getty Images; 19. The Invention of the Art of Drawing by Joseph-Benoît Suvée © Lukas - Art in Flanders VZW / Bridgeman Images; 20. Qin Shi Huang © British Library Board. All Rights Reserved / Bridgeman Images; 21. Terracotta Army © Jean-Pierre De Mann/ Publisher Mix / Getty Images; 22 left. Terracotta Warrior, Infantryman © akg-images / Laurent Lecat; 22 middle. Terracotta Warrior, Crossbow Marksman © akg-images / Laurent Lecat;

© akg-images / Album / Miguel Raurich; 71. Sancaklar Mosque ©
EAA-Emre Arolat Architecture/ Thomas Mayer; 72. Cave of Hira
© Dilek Mermer / Anadolu Agency / Getty Images; 73. Interior
of Sancaklar Mosque © isa_ozdere / iStock Editorial / Getty
Images Plus; 74. Interior of the Sultan Ahmed Mosque © Claudio
Beduschi / AGF / UIG via Getty Images; 75. Sultan Ahmed Mosque
© jackmalipan / Getty Images; 76. Dome of Sultan Ahmed Mosque
© age fotostock / Alamy Stock Photo; 77. Second Commandment,
Kennicott Bible © Bodleian Library, University of Oxford 2018
MS_Kennicott_1_fol_47r; 78. Jonah, Kennicott Bible © Bodleian
Library, University of Oxford 2018 MS_Kennicott_1_fol_305r;
79. Micrography, Kennicott Bible © Bodleian Library, University
of Oxford 2018 MS_Kennicott_1_fol_317v; 80. King David,
Kennicott Bible © Bodleian Library, University of Oxford 2018
MS_Kennicott_1_fol_185r; 81. Joseph Ibn Hayyim, Kennicott Bible
© Bodleian Library, University of Oxford 2018 MS_Kennicott_1_
fol_447r; 82. Hagia Eirene Church © EvrenKalinbacak / iStock
/ Getty Images Plus; 83. The lantern of Ely Cathedral © Rob_
Ellis / iStock / Getty Images Plus; 84. Iconoclasm in Lady Chapel
© BBC/Nutopia; 85. Ely Cathedral Lady Chapel interior © Angelo
Hornak / Alamy Stock Photo; 86. Minaret of the Quwwat-ul-Islam
Mosque © Roland and Sabrina Michaud / akg-images; 87. Hindu
Columns incorporated into the Quwwat ul-Islam Mosque © Charles
O. Cecil / Alamy Stock Photo; 88. Aerial view of the Acropolis
© Lingbeek / Getty Images; 89. UNESCO Logo © UNESCO; 90.
View of the Parthenon with the mosque from the northwest, 1836,
Christian Hansen © akg-images; 91. Mary Beard at the Acropolis
© BBC/Nutopia; 92. Kenneth Clark at Notre Dame, 1969 © BBC.

While every effort has been made to contact copyright-holders of
illustrations, the author and publishers would be grateful for information
about any illustrations where they have been unable to trace them, and
would be glad to make amendments in further editions.

INDEX